SPEAKERS' CORNER

First published 2015

The History Press
The Mill, Brimscombe Port
Stroud, Gloucestershire, GL5 2QG
www.thehistorypress.co.uk

British Library Cataloguing in Publication Data.
A catalogue record for this book is available from the British Library.

ISBN 978 0 7509 6106 6

Typesetting and origination by The History Press
Printed in Great Britain

SPEAKERS' CORNER

DEBATE, DEMOCRACY AND DISTURBING THE PEACE

PHILIP WOLMUTH

The History Press

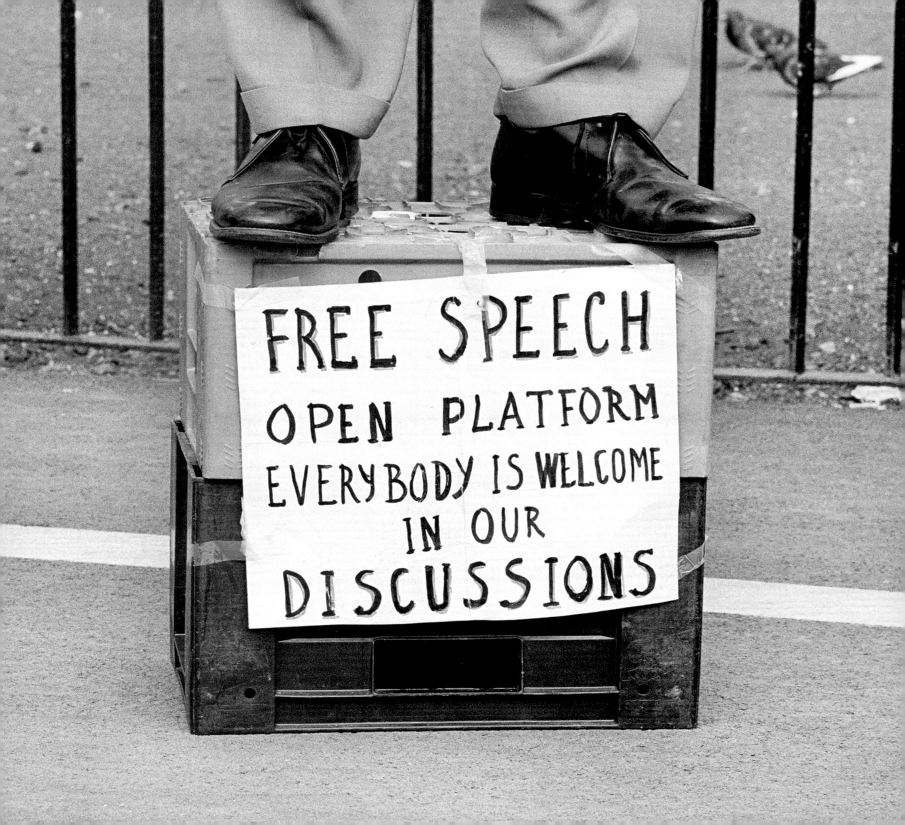

EPIGRAPH

'I spoke from the platform of the London Anarchist Group at Hyde Park practically every Sunday from 1947 to 1960, come rain or shine, and … over those thirteen years I must have spoken well over five hundred times, uttering millions of words to thousands of people … its real importance is not as a place from which people tell the government what to do, but as a meeting place for the people to talk to each other. The face-to-face public meeting, whether indoors or out, remains the only true means available for the immediate and spontaneous exchange of ideas.'

Philip Sansom, 'Foreword', Speakers' Corner: An Anthology,
Jim Huggon (ed.), Kropotkin's Lighthouse Publications, 1977

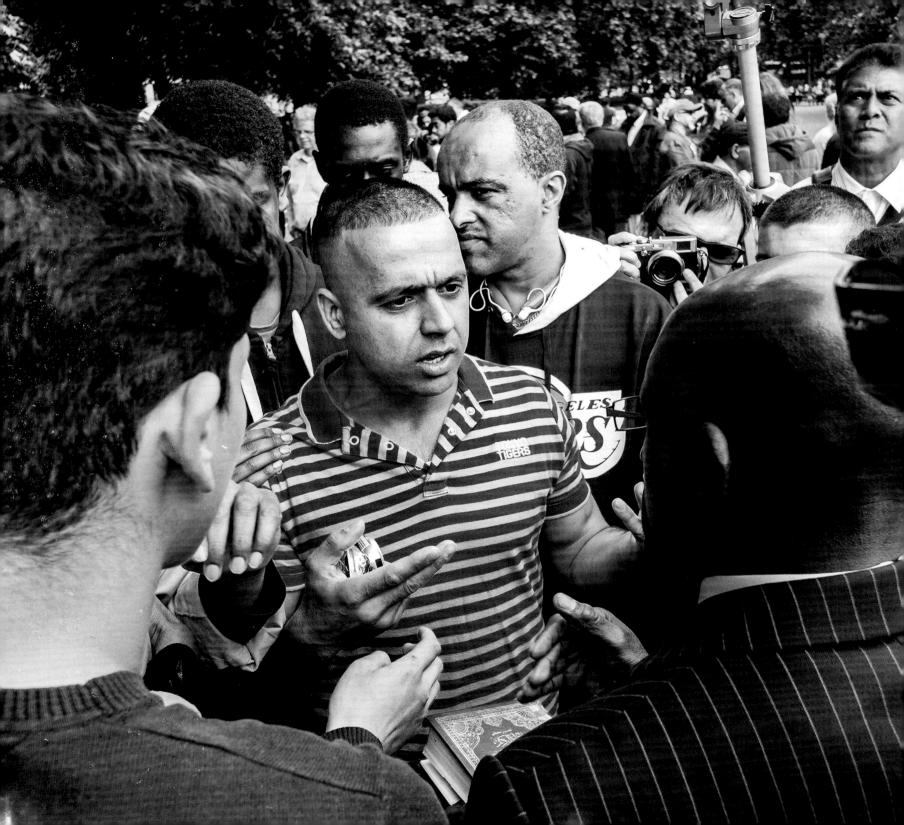

DEBATE, DEMOCRACY AND DISTURBING THE PEACE

When I first visited Speakers' Corner in 1977 it seemed just as George Orwell had described it in 1945 – the resort of preachers, eccentrics and 'a large variety of plain lunatics'.[1] On this world-famous patch of concrete and grass, a great number of speakers were standing on bespoke platforms, ladders, or upturned milk crates, shouting across each other to attract the attention of a sizeable motley crowd of onlookers. Hecklers shouted back. Others walked about clutching placards proclaiming the end of the world, or calling the wrath of God down upon unrepentant sinners. The cacophony was bewildering.

But I soon came to see that something unusual was happening in this north-eastern corner of London's Hyde Park: genuine, unmediated public debate. At the edges of the crowd, small knots of people engaged in intense discussion, oblivious to the mayhem around them. Even within some of the larger gatherings it was possible to hear serious exchanges of ideas, albeit frequently interspersed with much foolishness.

Despite the arrival of the online social media platforms that have recently become such ubiquitous features of our everyday lives, this is rare: we still live in an age in which the mass media largely set the parameters of public discussion. At Speakers' Corner much of the talk strays well beyond those rarely challenged norms, and offers a very different perspective on 'public opinion'.

The subjects under discussion were then – and still are – almost entirely unrelated to day-to-day news headlines. At least half the speakers are preachers; issues of race, religion and nationality are discussed obsessively. Many regular visitors agree that the place has changed over the years: the Sunday afternoon crowds are smaller; there are fewer platforms and a narrower range of speakers, and the proportion of religious meetings has increased. The demographics of both speakers and crowd have also shifted: now at least as many of the preachers are Muslim as Christian. Nevertheless, despite these changes, Speakers' Corner retains the unique buzz generated by the intensity and eccentricity of face-to-face argument.

Perhaps the most essential feature of such argument, conducted by ordinary people talking to each other in the same place at the same time, was best described by Lord Donald Soper, Methodist minister, socialist and pacifist, who spoke regularly at Speakers' Corner from 1926 until his death in 1998. Soper believed passionately in what he called 'the fellowship of controversy':

> It is one of the most important of all the avocations of any religious faith or any political party. You can be compelled to say what you mean, and cannot get away with the fact that it sounds important. The great difference is: you can't answer back to the television![2]

There was a time when such debate was not confined to Hyde Park. Speakers' Corner is all that remains of a long tradition of public meetings in parks and on street corners at which ordinary people could listen to orators, political campaigners and preachers, and participate in discussions on all manner of subjects – political, religious, and otherwise topical.

These outdoor gatherings date back at least as far as the Methodist and other dissenting field-preachers of the late eighteenth and early nineteenth centuries, and were commonplace in cities and towns across the UK until the early twentieth century. According to political historian Stephen Coleman[3], between 1885 and 1939 there were around 100 open-air meetings a week in London alone. After the Second World War they gradually disappeared, in parallel with the rise of radio and television, leaving Speakers' Corner as the sole survivor.

Perhaps its longevity has something to do with the park's central location and its history as a focal point for popular protest. Its status as a public speaking and meeting place was established in law by the 1872 Parks Regulation Act, but by then it had already served unofficially as such for some considerable time. Nevertheless, the passing of the Act was an important victory in the struggle for democratic rights.

The sequence of events that led up to it began in 1866, when the government banned a Reform League demonstration calling for universal male suffrage. Finding the park locked, demonstrators tore up hundreds of yards of railings, stripping the fence from almost the whole length of Park Lane. Having gained access, they were attacked by police, 12,000 special constables, and military reinforcements. The rioting that followed lasted three days. The following year, when a crowd of 150,000 defied another ban, police and troops did not dare intervene; the government was humiliated, and Home Secretary Spencer Walpole resigned the next day.[4] Pressured by threats of further popular unrest, the government passed the Second Reform Act later the same year, doubling the number of men eligible to vote to 2 million – 40 per cent of the adult male population.

Democratic rights were again the issue when a crowd of 500,000 converged on the park in 1908 to demand votes for women, a landmark event in the campaign which led to the Representation of the People Acts of 1918 and 1928, the second of which finally gave women the same voting rights as men. At the 1908 mass rally, eighty speakers addressed sections of the crowd simultaneously from twenty platforms spread out across the grass. Even with an audience of hundreds of thousands, the interaction was face-to-face, and contemporary descriptions indicate an element of confrontational heckling and knockabout banter, even at a gathering with such serious purpose, that has much in common with present-day Speakers' Corner:

> … rowdies singled out Mrs Pankhurst and Mrs Martel … Mrs Martel's wagon was almost overturned and two sailors, one on the other's shoulders, made constant interruptions at Mrs Pankhurst's platform. When she mentioned married women, one of them bellowed, 'Wives? Why I've got four – all in different ports!' Then a bell rang and two men in the middle of the crowd started a wrestling match.[5]

The religious element that is so immediately evident today is also not new. In April 1894, *The Globe* newspaper reported:

> Yesterday afternoon a disorderly scene took place in Hyde Park. Two persons who were endeavouring to hold a religious meeting near the Serpentine were surrounded by a crowd of men and boys, and, owing to some peculiarity, were frequently interrupted and prevented from proceeding with the service they were attempting to conduct. Finally, the opposition became so demonstrative that the two men were compelled to beat a retreat, a small banner they had with them being torn. Their hats were knocked off, and they were otherwise subjected to considerable hustling and ill-usage.[6]

Some fifty years later, not much had changed. According to Fred McKay, a regular at Hyde Park from 1946 until the late 1960s, when you went to the park soon after the Second World War:

> If you wanted serious talk you could go and get it. If you wanted religion, you could get that. If you wanted anti-religion you could get that, and if you wanted nonsense, you could get as much nonsense as you wanted.[7]

A member of the Communist Party and the National Secular Society, and later president of the breakaway London Secular League – all of which had platforms in the park – in the 1940s McKay heard speakers from the Connolly Association, the United Irishmen, the Communist Party, the Revolutionary Communist Party, and the Socialist Party of Great Britain (SPGB). Others spoke on Indian Nationalism, anti-colonial struggles in Africa, or proposed solutions to the housing crisis.

The decline in the number of speakers and the size of the crowds since then, and particularly over the period covered in this book (1977–2014), has been significant. Some speakers, hecklers and observers have attended regularly throughout, but where once a summer Sunday afternoon would commonly attract forty or fifty speakers, today there might be fifteen or twenty, and audiences have fallen from 1,000 or more to 200–300. The Hyde Park Gay and Sapphic Society, the Hyde Park Anarchist Forum and the London Secular League have all gone. One perhaps puzzling constant is the predominance of male voices: despite some notable women speakers and hecklers, they remain a minority. However, although the occasional appearance of the SPGB platform is the only remaining sign of an organised political group, and the proportion of religious discussions has risen to somewhere close to 80 per cent, a variety of serious (and not so serious) secular speakers and debaters can still be found at Speakers' Corner.

The meetings of Heiko Khoo, a Marxist who has spoken in Hyde Park since 1986, draw some of the biggest crowds with erudite but accessible discussions on global political and economic issues. The anarchist Tony Allen, who made the transition from heckler to speaker in the mid-1970s, and writer, film-maker and internationalist Ishmahil Blagrove, who first took to a ladder in the 1980s, can both still be heard from time to time. Blagrove was one of a new generation of young black British speakers who came to talk, heckle and debate on issues of racism, imperialism and black identity in the 1980s and 1990s – sometimes in anger, often with great humour – and others with similar views also still make occasional visits. A new feature of the last ten years are intense political discussions conducted in Arabic: frustrating for non-Arabic speakers, but a reflection of the demographic changes in London as a whole, and particularly of the area neighbouring Hyde Park. And despite most consisting of little more than knockabout blasphemous exchanges between rival faiths (principally Christian and Muslim), even some of the religious debates can become intriguingly philosophical.

So although there is a clear separation between the meetings in the speaking area and the mass protests that occasionally rally on the park's larger grassed expanses, and Speakers' Corner no longer plays any significant role in day-to-day political life, it remains a unique arena for authentic public debate, with a special place in the history of the struggle for democracy in Britain.

It is easy to forget that, despite well-worn platitudes regarding our long democratic tradition, for the majority of the common people the right to free assembly, free speech, and even the right to vote, are relatively recent acquisitions. When Donald Soper stood up to speak at his first Hyde Park meeting, women under 30 did not yet have the vote. Many of the democratic rights we now take for granted, including the right to engage in the 'fellowship of controversy', were won only after long battles, some of the most significant of which took place in Hyde Park itself.

The cacophony that greets the present-day visitor to Speakers' Corner thus has an illustrious history, and the apparent mayhem can be seen, on closer inspection, to be a remarkable example of self-regulating, anarchic, collective expression. Whether they are aware of it or not, the speakers, hecklers and regular and irregular visitors that congregate there each week are the vibrant heirs of those who fought for, and won, the rights to freedom of expression and assembly, thereby establishing the park's worldwide reputation as the home of free speech. It is a legacy worth cherishing.

1 George Orwell, *Freedom of the Park*, Tribune, 7 December 1945
2 Lord Soper, interview with the author, 1994
3 Stephen Coleman, *Stilled Tongues*, Porcupine Press, 1997
4 Royden Harrison, *Before the Socialists: Studies in Labour and Politics in England 1861–1881*, Routledge and Kegan Paul, 1965
5 Antonia Raeburn, *Militant Suffragettes*, Michael Joseph, 1973
6 Reprinted in John Ashton, *Hyde Park from Domesday Book to Date*, Downey, 1896
7 Fred McKay, interview with the author, 1995

Note On The Texts

The quotations which appear alongside the photographs are taken from the author's contemporaneous recordings of speeches, heckles, discussions and arguments spoken by, or addressed to, those photographed.

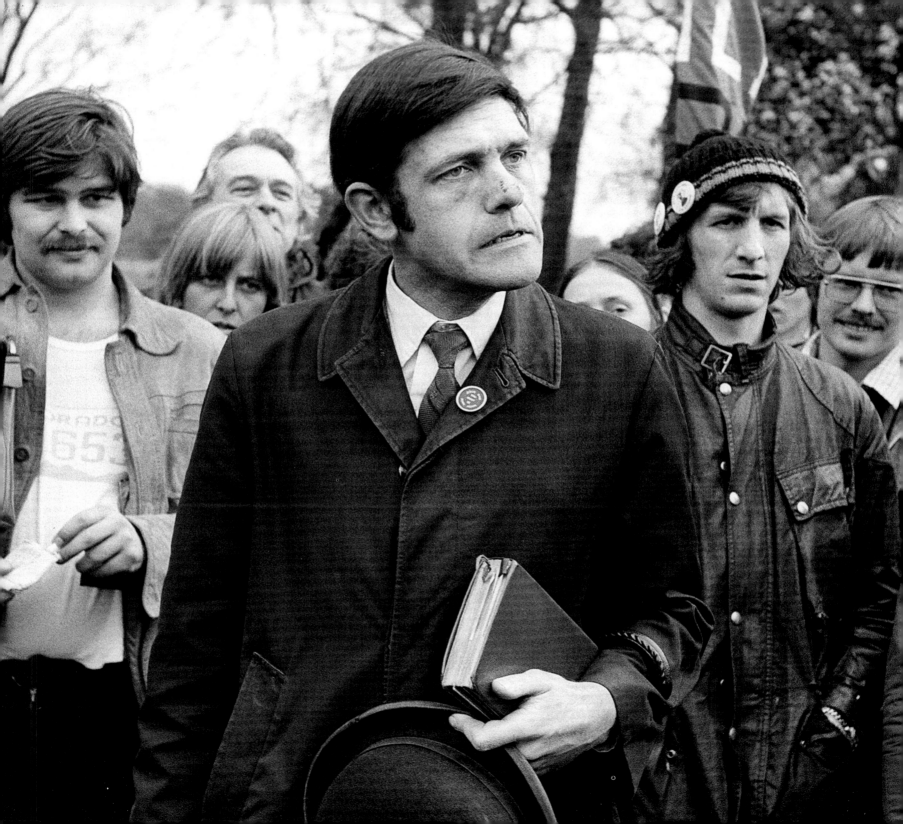

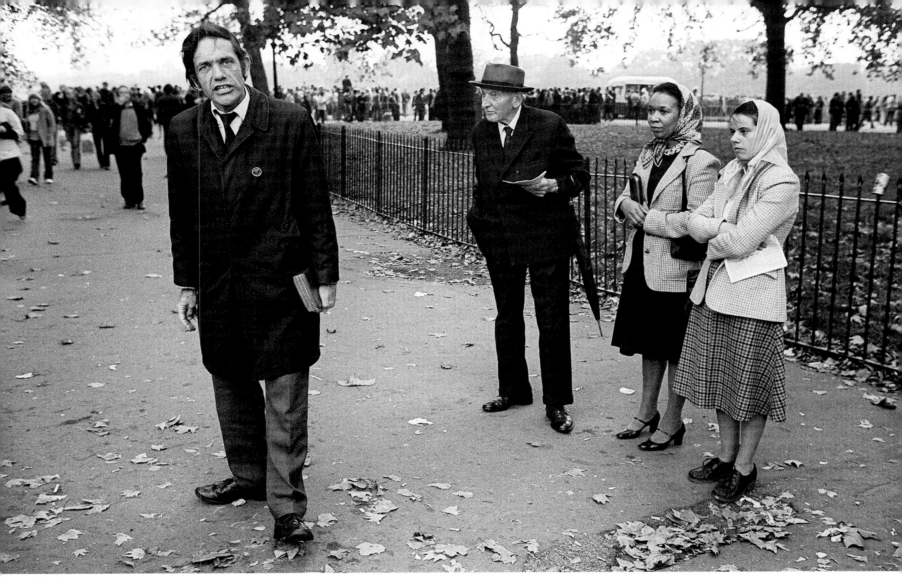

Stuart Wheeler, born-again Christian, 1978.

Heckler: Who gives the orders around here?
Stuart Wheeler: I give the orders, Mister, not you. Praise God. The Bible says law-breakers shall be punished, and if I want to call the police, I will call the police, according to what it says in my Holy Bible; according to what God says. The Bible says law-breakers will be punished. Because I was punished, many years ago when I was a criminal in a maximum security gaol. And that certainly wasn't very funny.

Heckler: How did you escape?
Stuart Wheeler: After I'd done my time, Mister, I got out and I wondered: what was life all about? How did I ever get in a place like this? And then I found it all out, on my knees in an empty church, on the outskirts of Coventry. And I wept the place down, in front of my God, all on my own. And I said, 'God have mercy on me. What a sinner I am.'

11

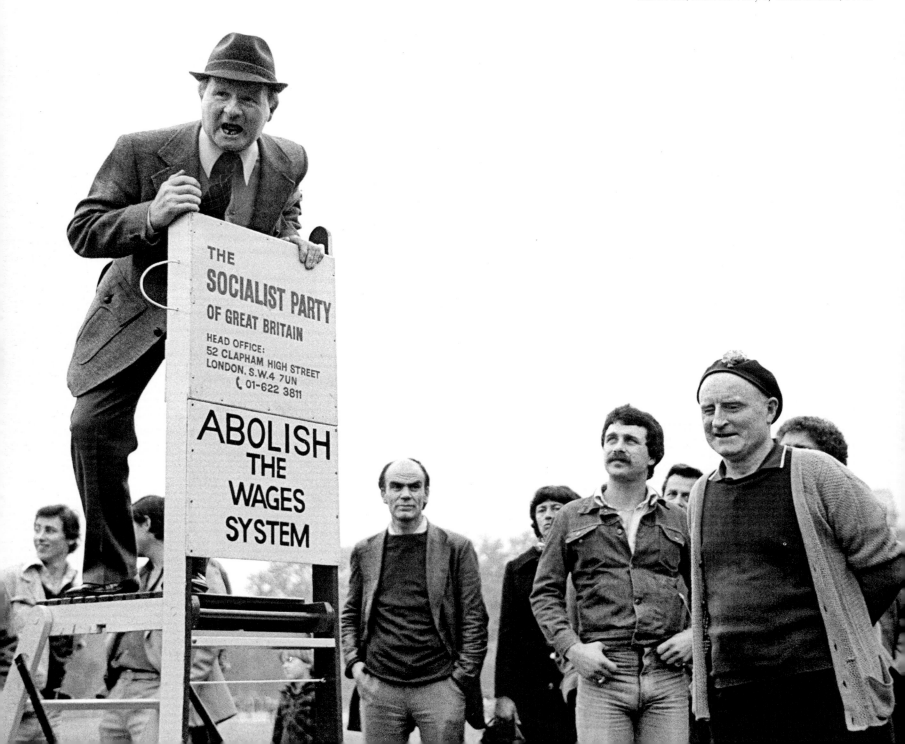

Steve Ross, Socialist Party of Great Britain, 1978.

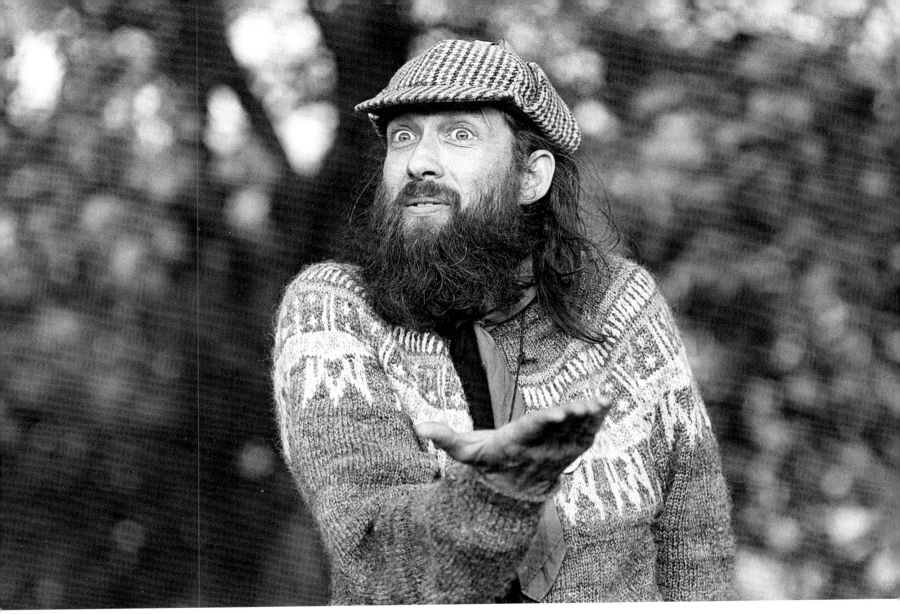

Jim Huggon, Hyde Park Anarchist Forum, 1981.

Jim Huggon: People ask me, 'How do you become an Anarchist?' Well, it's not easy. You can't rearrange the whole fabric of Western civilisation just like that. For a start, it's against the law. So you'll need to practice. To begin with try breaking a few little laws: ride your bike home at night with no lights on; walk on the grass. Then, as you get more confident, move on to bigger things: commit a public nuisance; disturb the queen's peace. Keep practising, and before long you'll be robbing banks and overthrowing governments!

13

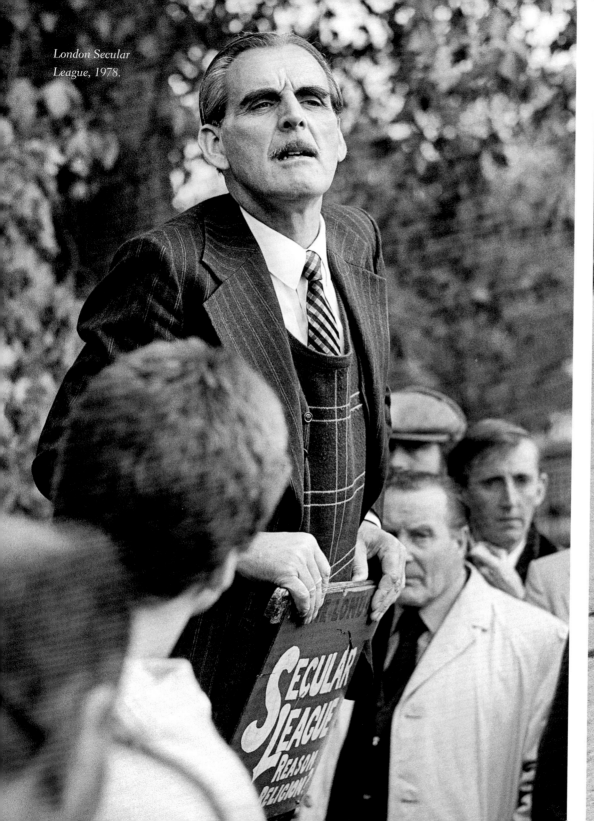

London Secular League, 1978.

Jesus said —

When ye pray

Use not V-A-I-N R-E-P-E-T-I-T-I-O-N-S as the heathen do: for they think that they shall be heard for their MUCH speaking.

Be not therefore like unto them.
See Holy Bible. Matthew Chap 6

Note

No mention whatever of praying to the Virgin Mary is in the Holy Bible

The Apostles never taught or practised such things

The Apostles did teach:-
No man cometh unto the Father but by Jesus Christ

Holy Bible. John 14. 6.

And in none other is there any Salvation: for neither is there any other name under Heaven that is given among men, wherein we must be saved
Holy Bible. Acts 4.

Anti-Catholic, 1977.

Peter England: What country are you from?
Heckler: New Zealand.
Peter England: New Zealand! That's not a country! There's only 3 million people in New Zealand! What sort of country would call its capital after a BOOT? Do you know, they've got two languages in New Zealand: English, and SHEEP! Do you know they've got a rugby team called the All Blacks, and there isn't a black man among them! What sort of country is that then?

Peter England, 1977.

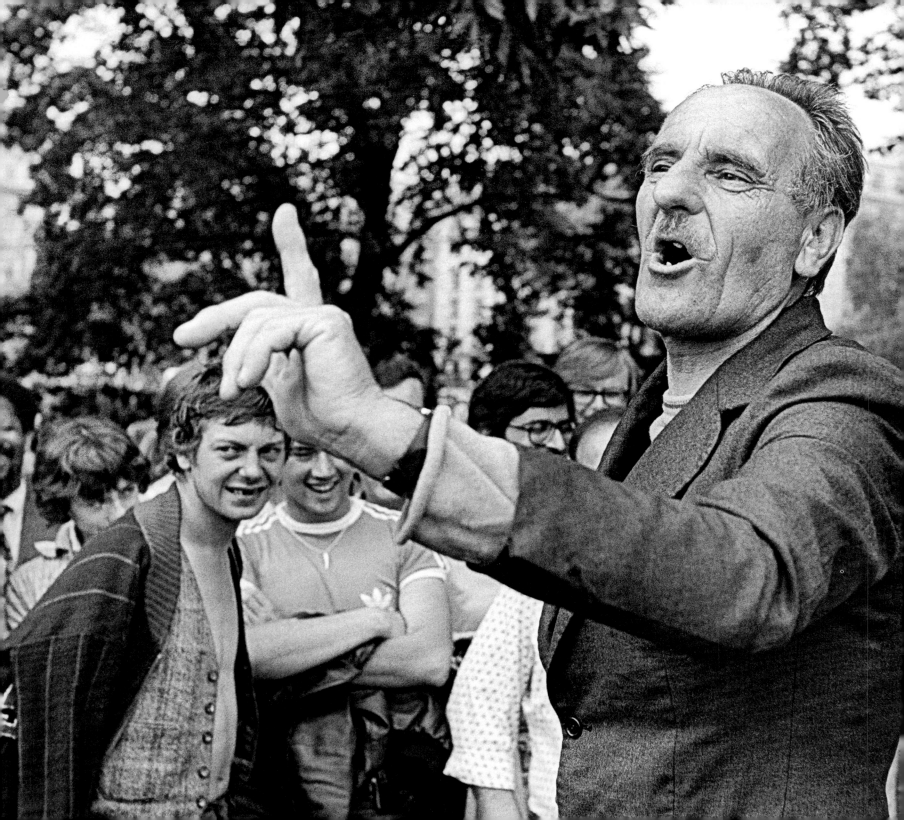

Geoffrey Smith, National Gypsy Council, 1978.

Peter Bhalla, communist, 1978.

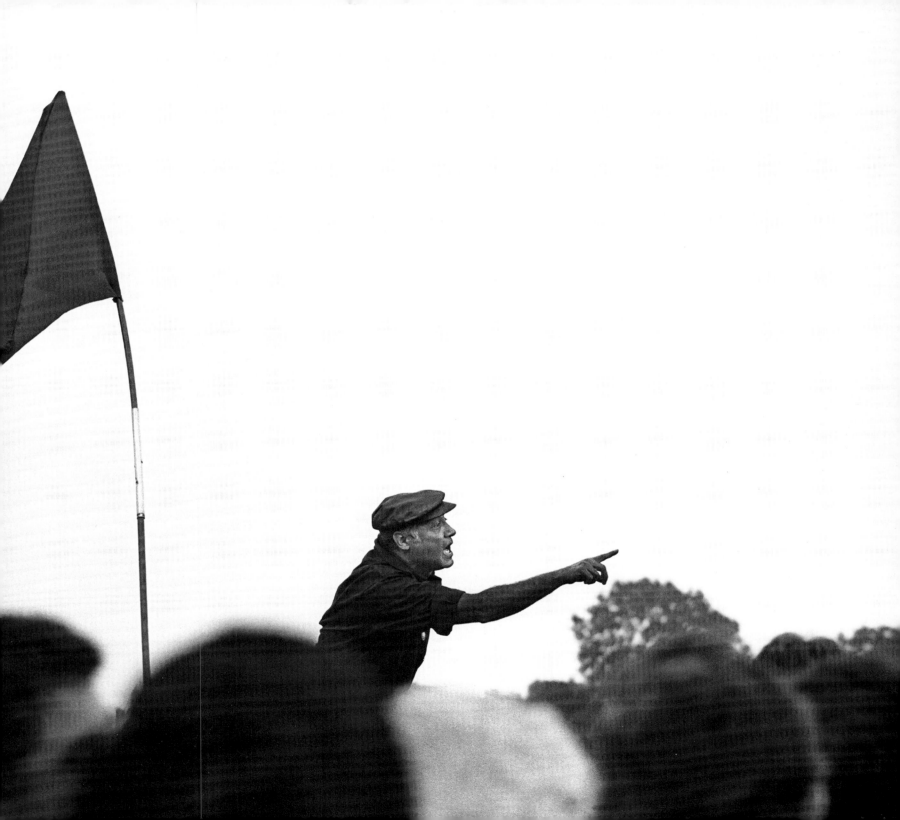

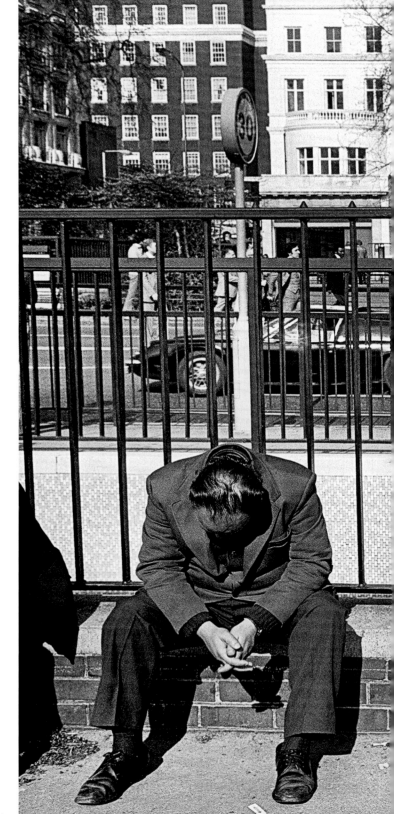

Holy Bob, evangelical Christian, 1978.

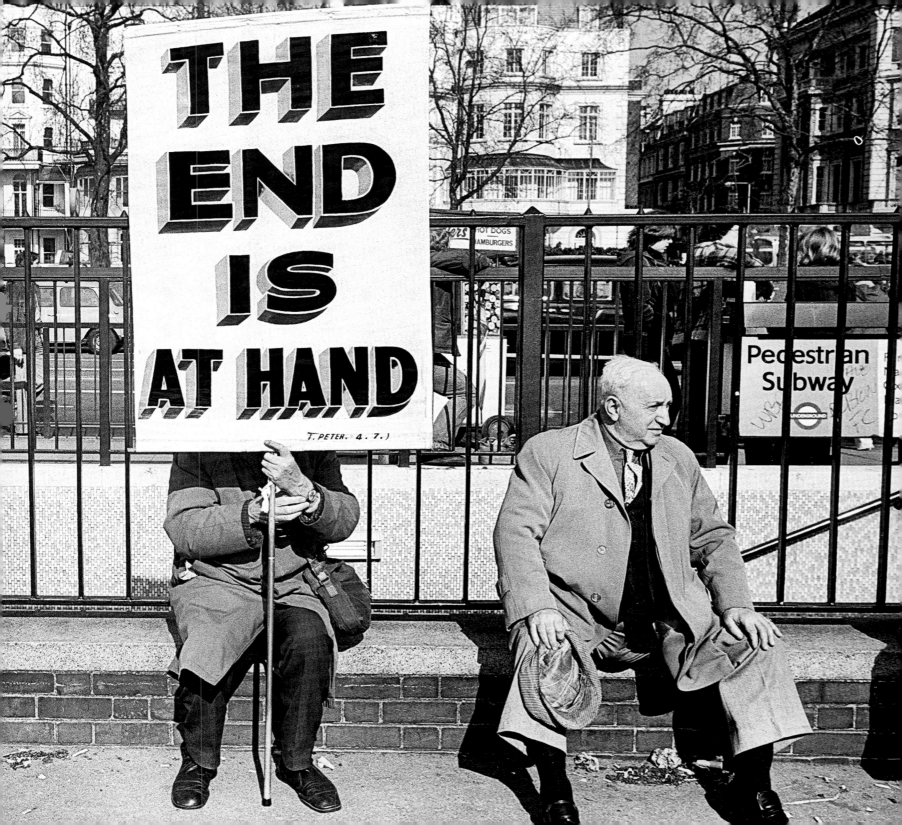

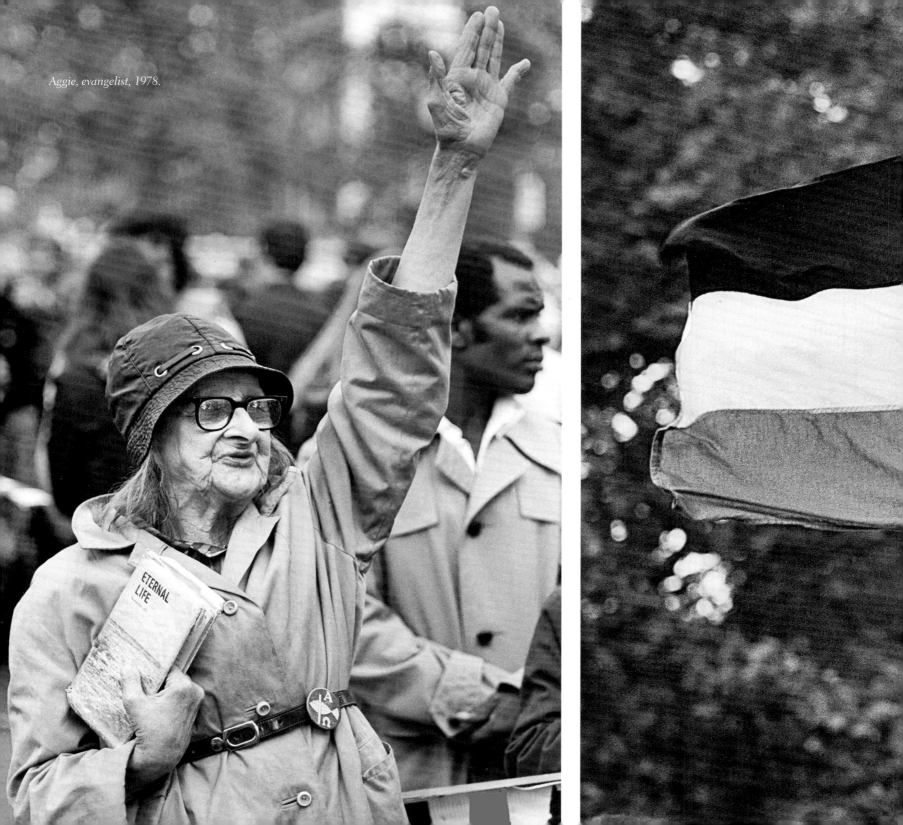

Aggie, evangelist, 1978.

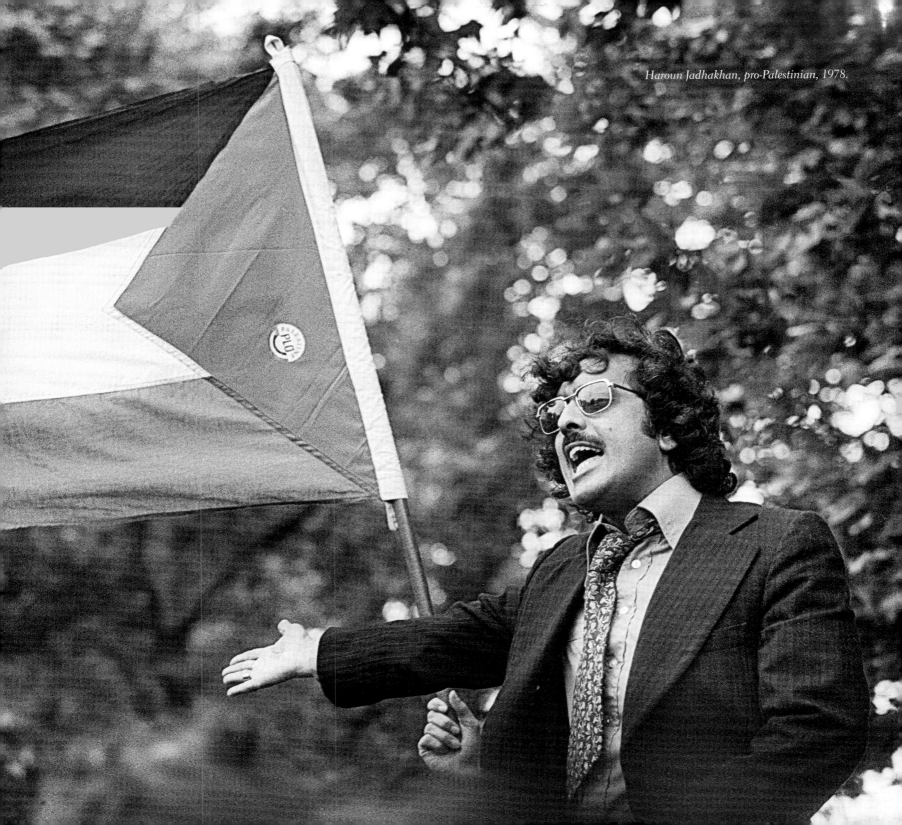

Haroun Jadhakhan, pro-Palestinian, 1978.

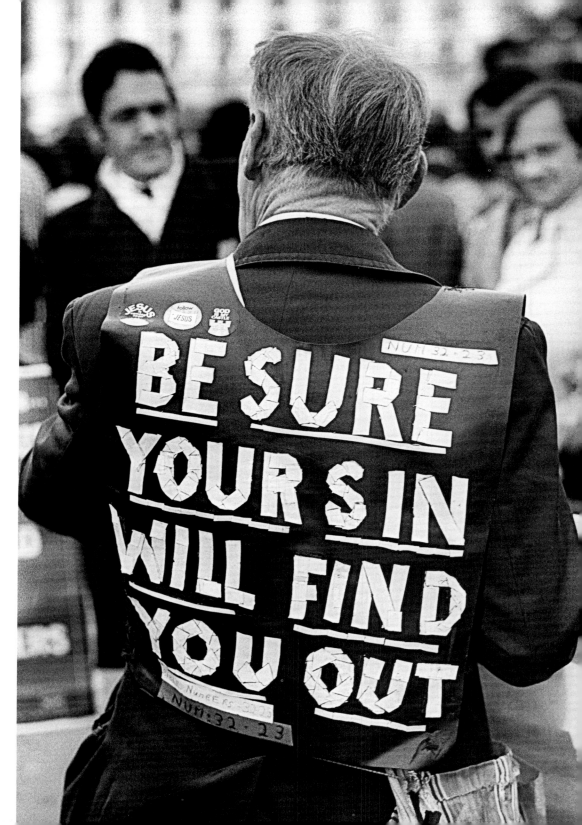

Born-again Christian, 1977.

Norman Schlund: So we might as well leave it at that. Or we could leave it at this. Or we could just leave it. But then it might not be here when we get back. Or we might not even come back. So we'd better take it with us!

Norman Schlund, 1979.

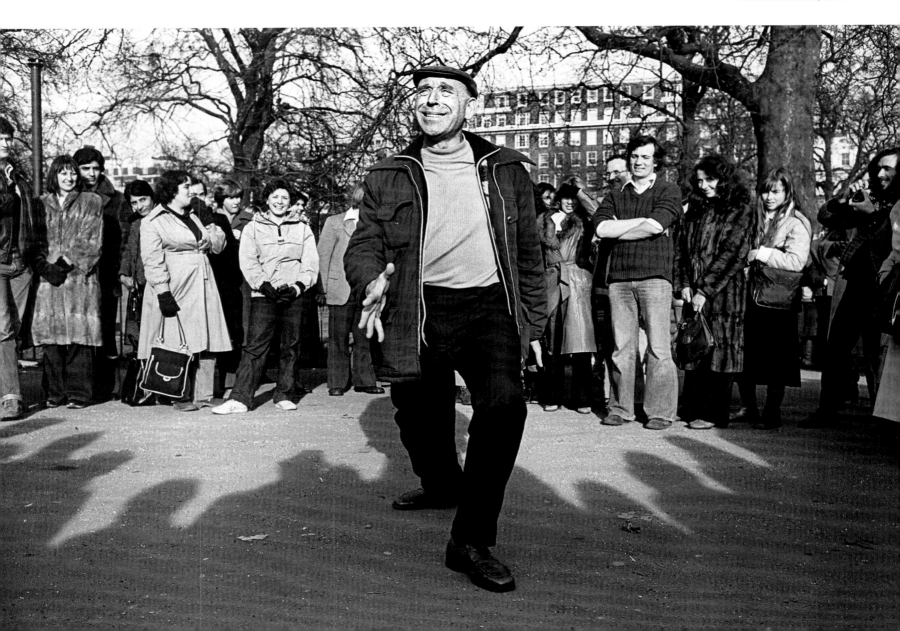

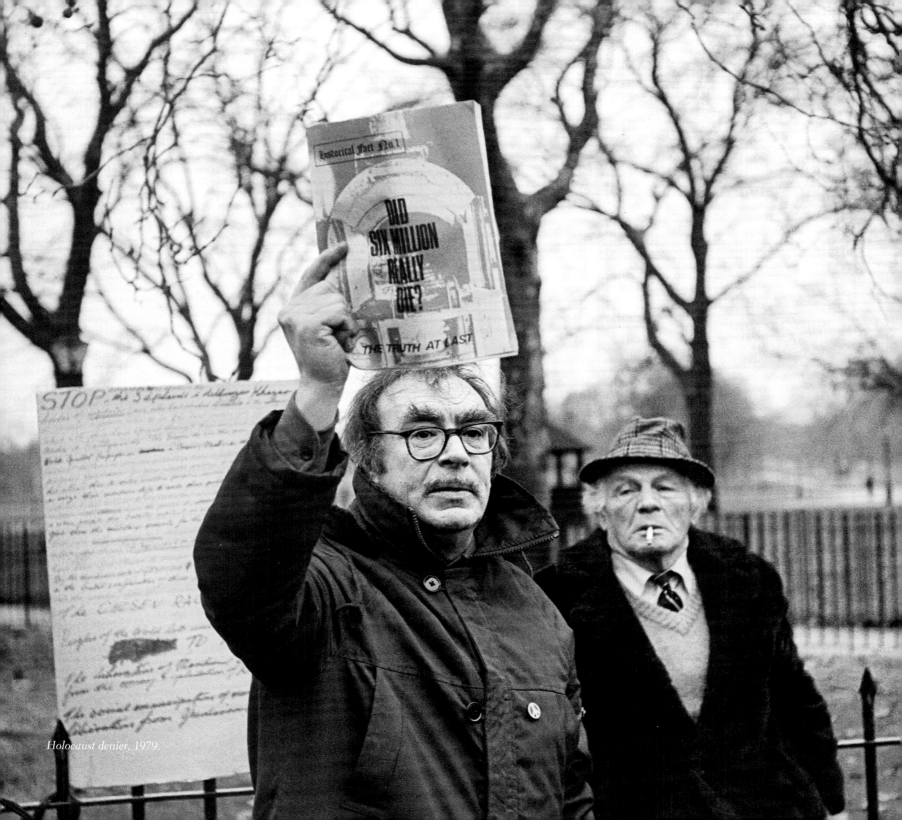

Holocaust denier, 1979.

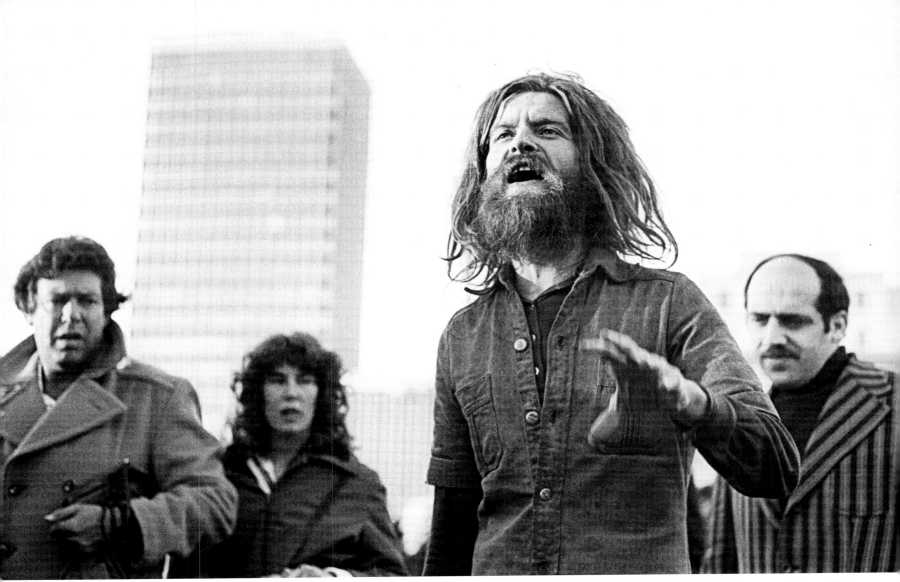

Joshua, 1979.

Joshua: ... so in the event of a showdown they would use this special weapon that they have, which is this STORED NOISE, which is a kind, almost, of POISONOUS NOISE, rather like you have poisonous gas, right, which is used, has been used, in wars, right, etcetera. And you've got bacteriological warfare techniques – all kinds of things were developed by the various military things, etcetera, right. And so, likewise, EMI came up with this new sort of thing which was a kind of NOISE poison, right, and they stored it in some place down in Tottenham Court Road. Now the only point is that it was supposed to also be radioactive, right, and it had similar effects to when radioactivity escapes from power stations, right, such as nuclear power stations, etcetera. So there was in actual fact a SIMILARITY between the nature of this radioactive sort of noise process, right, which they were storing in Tottenham Court Road. And this was reported quite early on in the press, but not too extensively.

29

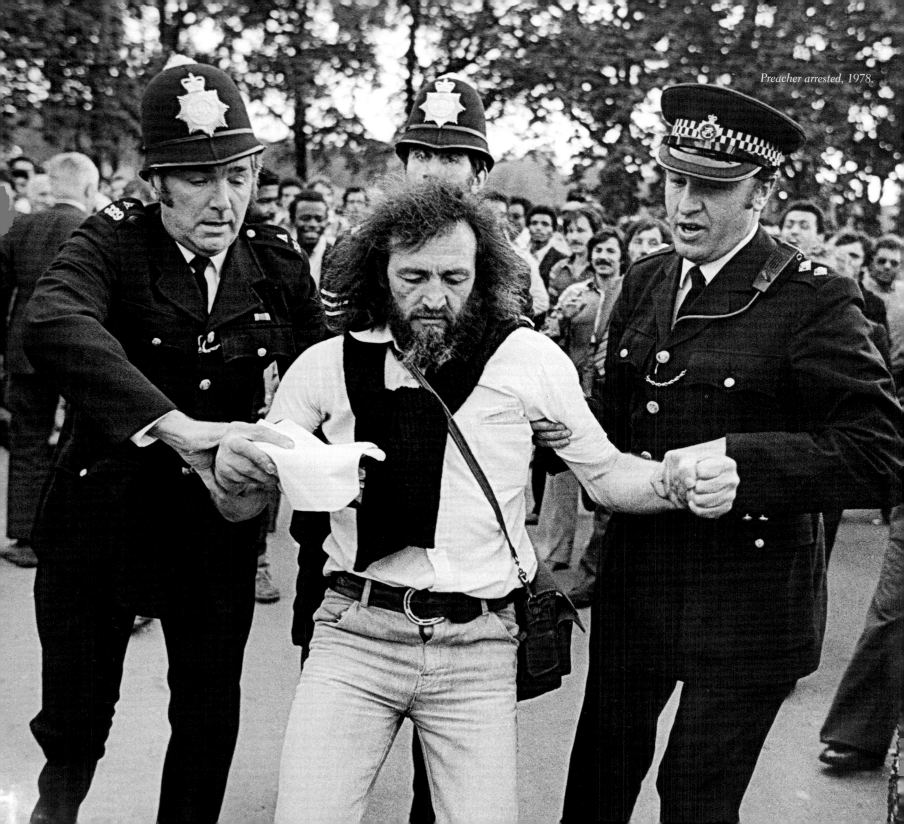

Preacher arrested, 1978.

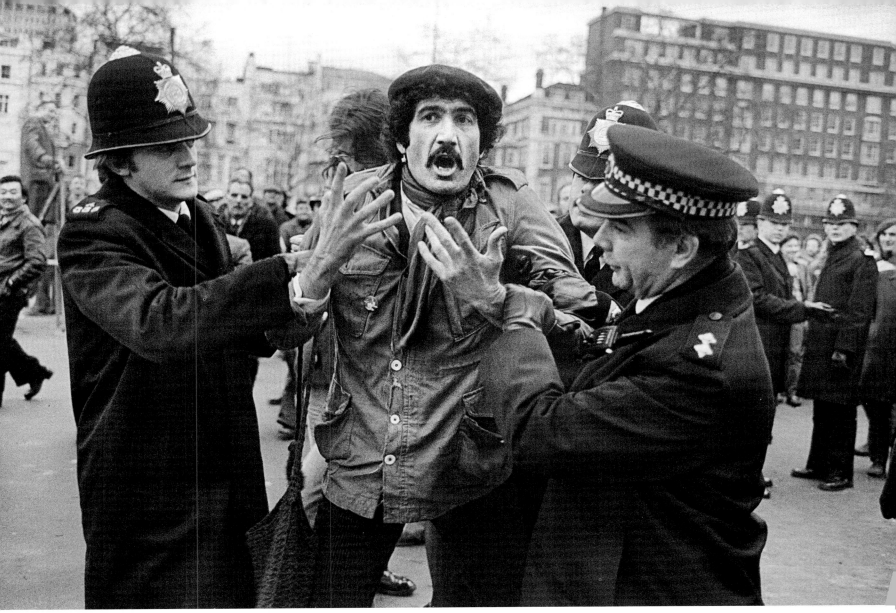

Tony Allen arrested, 1979.

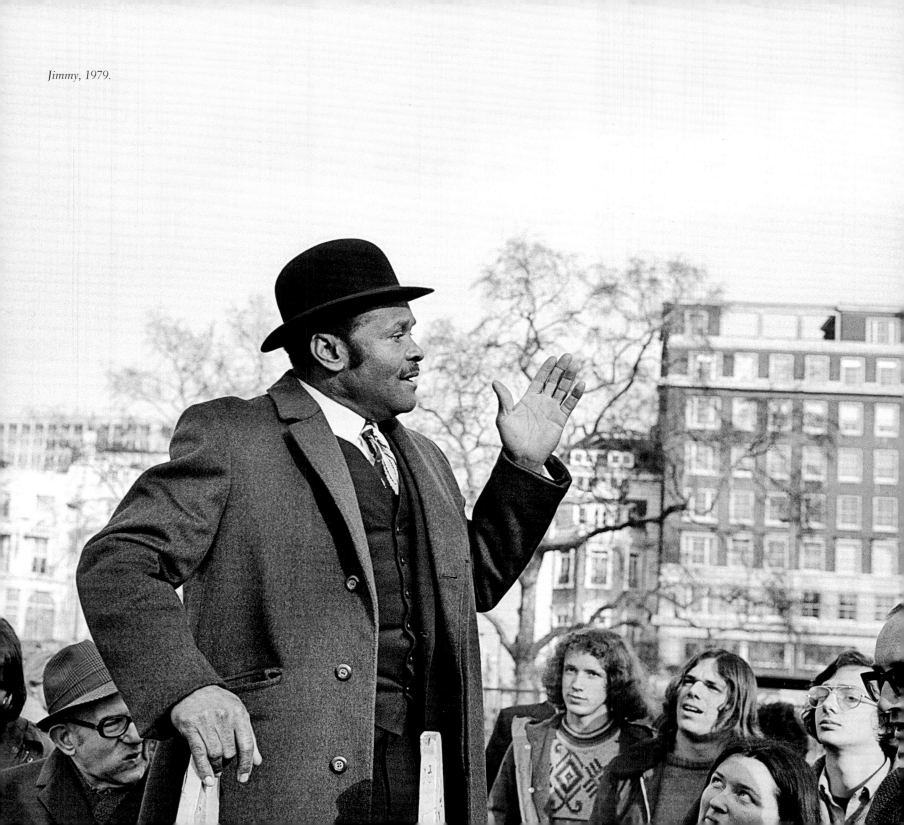

Jimmy, 1979.

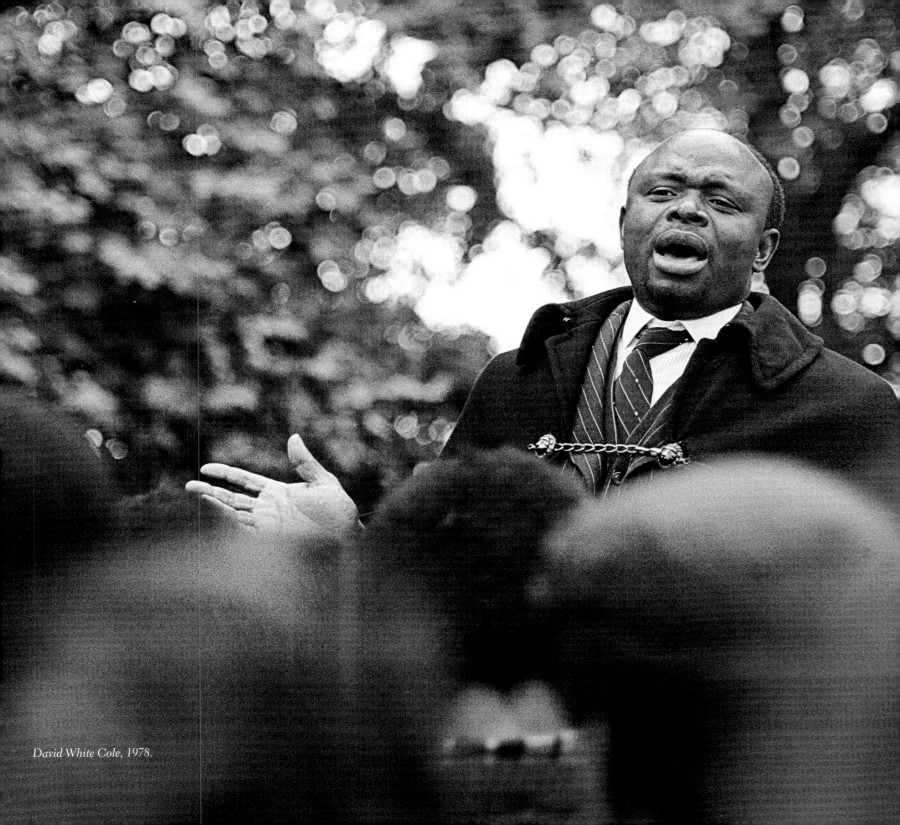

David White Cole, 1978.

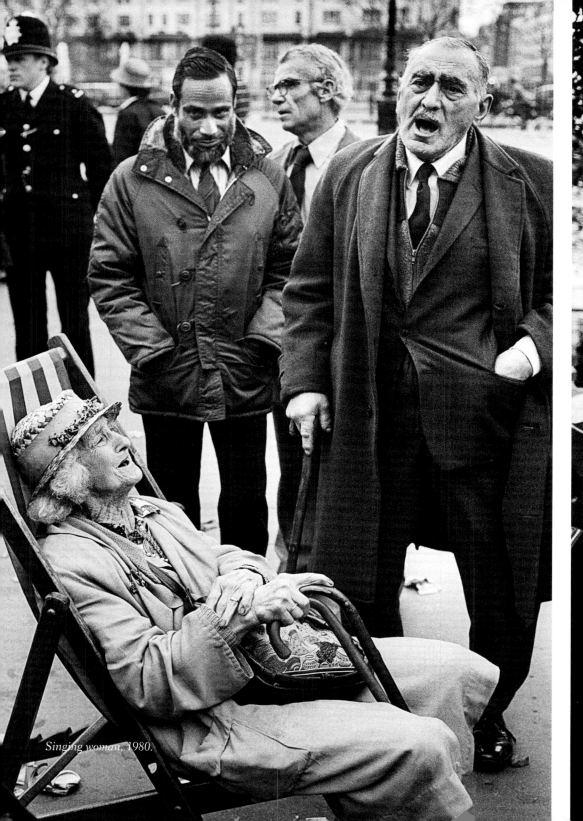

Singing woman, 1980.

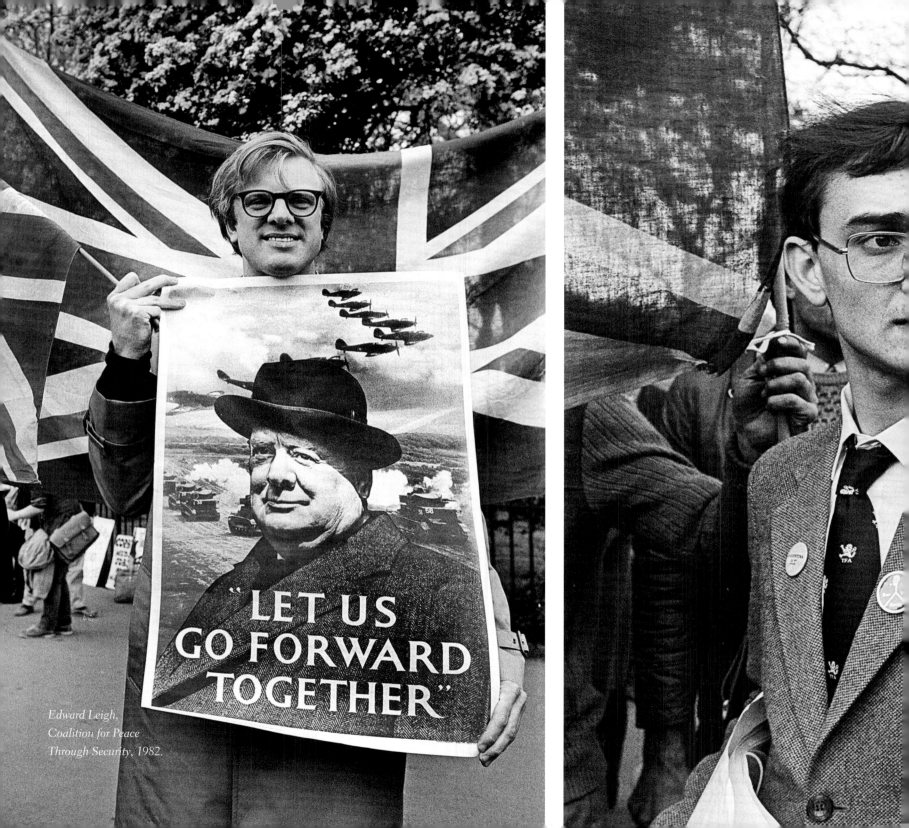

*Edward Leigh,
Coalition for Peace
Through Security, 1982.*

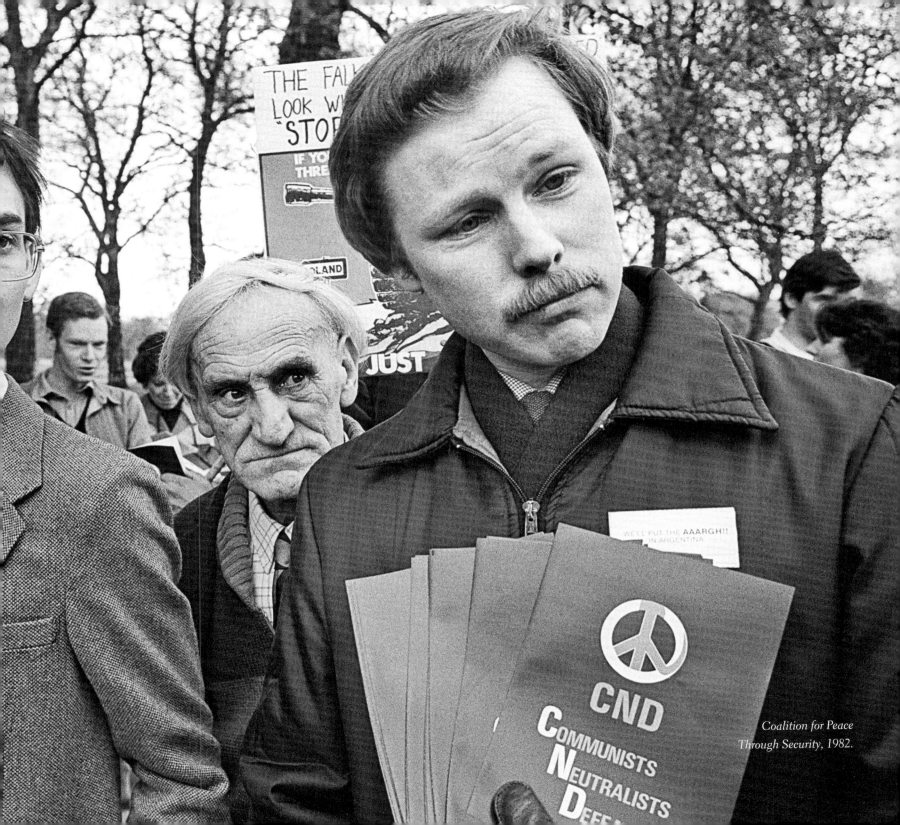

THE FAL[L]
LOOK W[...]
"STOP[...]

IF YO[U]
THRE[...]

[P]OLAND

JUST

WE'LL PUT THE AAARGH!!
IN ARGENTINA

☮
CND
COMMUNISTS
NEUTRALISTS
DEFE[...]

*Coalition for Peace
Through Security, 1982.*

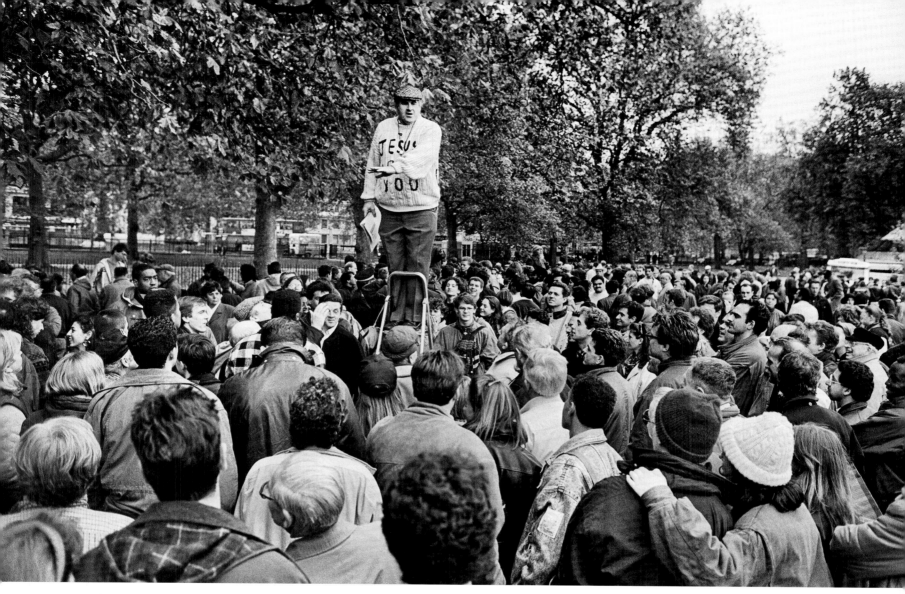

Paddy, Christian preacher, 1993.

Heckler: Jesus was an adulterer – he slept with Mary!
Paddy: Where did you read that? In the Koran? Well, everything in there is rubbish. You ought to read *The Beano*. *The Beano* makes more sense.
Second Heckler: If you had a brain you'd be dangerous!

Paddy: You want to believe in Jesus. He was a real man! He got nailed to the cross, then he got buried, then three days later he rose from the dead. There you've got a man!
Heckler: You're an idiot! He slept with another man's wife. God committed adultery with Mary. God treated Mary like a whore. You fool, you! Accept that God committed adultery!

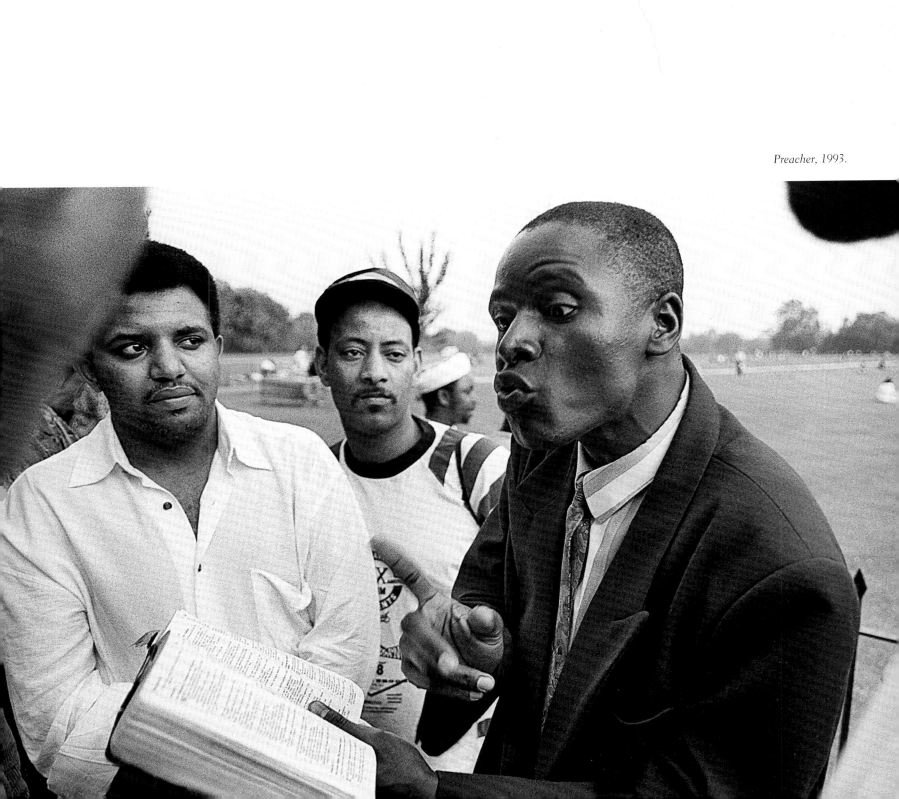

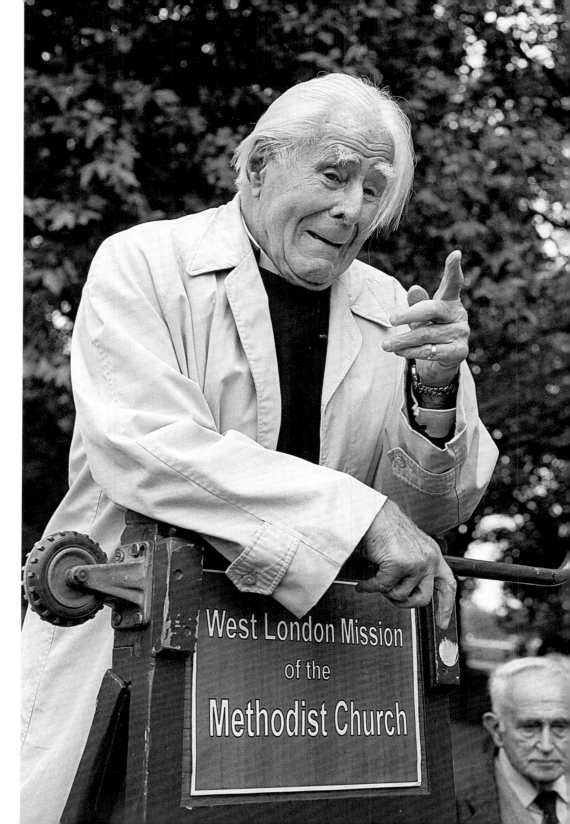

Lord Soper: Those who regard the Bible as an authoritative and final judgement should take the precaution of reading it, and should take the precaution of reading the various translations of it, before they talk the nonsense that the Bible is the word of God. What I have tried to say is – the discussion of moral values, the appeal for basic moral values, is a waste of time until you equate the ambition with a definition. What are these moral values that are so desirable? I believe that the cultivation of non-violence is perhaps the most imperative of all the requirements of morality today. I secondly believe that, until you provide, in education, the kind of moral values that are desirable, you're not likely to find them anywhere else. Now, I haven't got time to go on with that anymore. Thank you for standing around in the cold. I'll be here next week.

Lord Donald Soper, 1994.

40

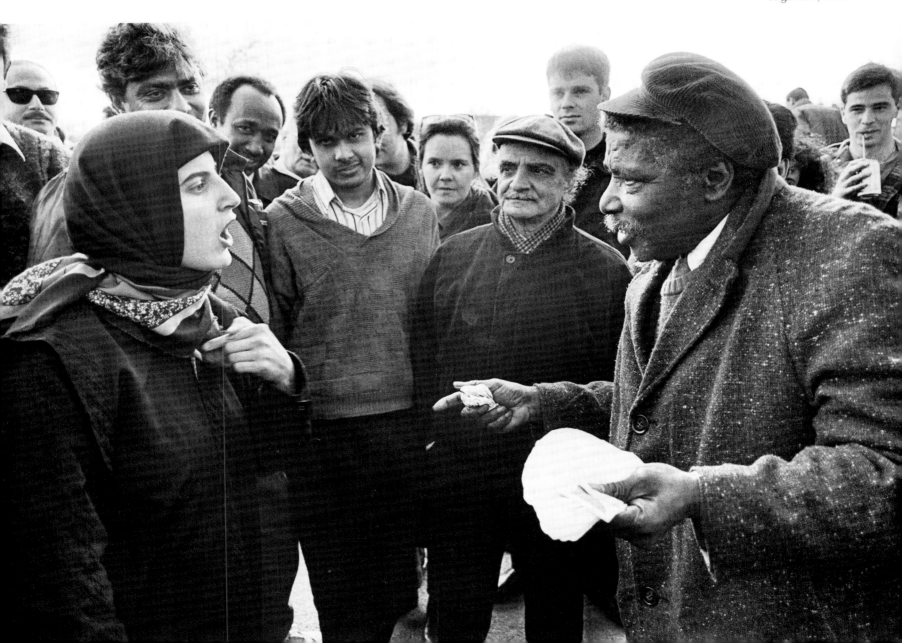

Argument, 1993.

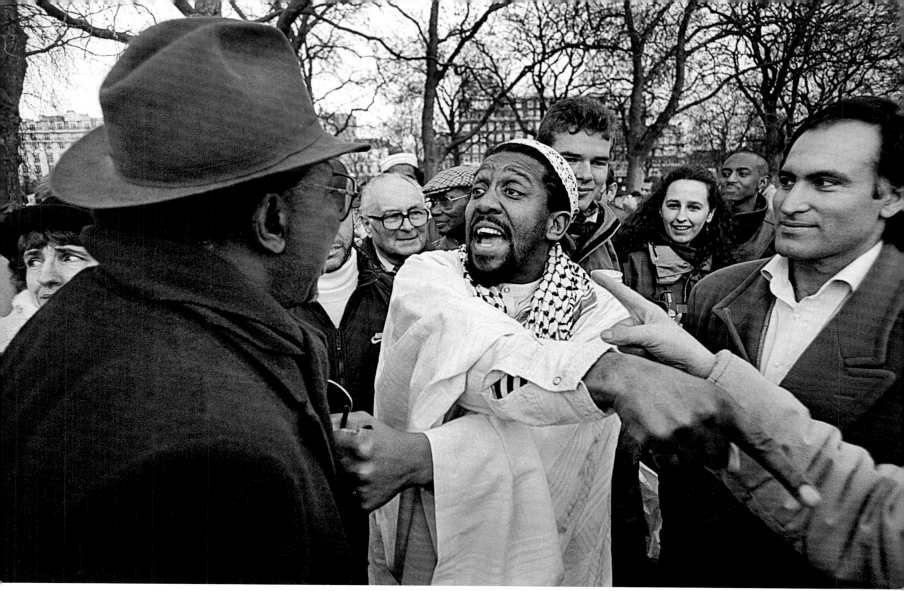

Islam v. Christianity argument, 1995.

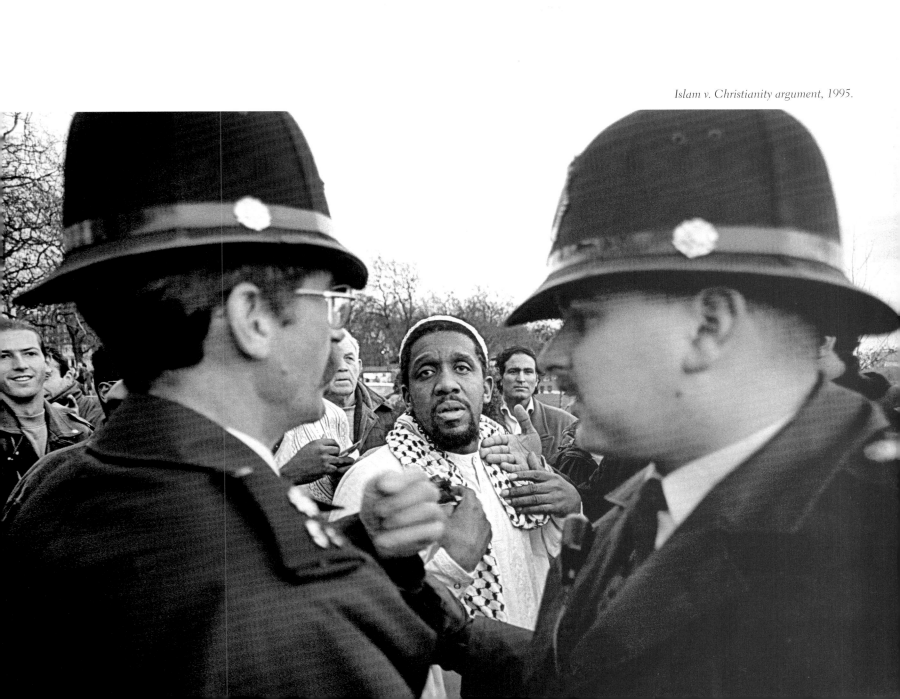

Islam v. Christianity argument, 1995.

Israeli resident: The trouble with you is you live in a foreign country. You live in England – are you English?

UK resident: I'm English, I'm Canadian, I'm Israeli. I have three passports.

Israeli resident: You are the wandering Jew. You're not English, you're not Canadian, you're not American. You're Jewish. You don't belong anywhere.

UK resident: I belong everywhere. The whole world is mine.

Israeli resident: You're a foreigner. You're a foreigner all over.

UK resident: But you're in the Middle East! You're living in the Arab world. You're surrounded by Arabs, and the Arabs don't want you to have that land.

Israeli resident: We come from there. It's our own land. I was born there, my parents were born there, my grandparents were born there! That's a fact!

UK resident: So what? I was born in Russia. I can go to Tel Aviv tomorrow, and an Arab can't go!

Israeli resident: So, you hate the Israelis!

UK resident: No, I don't hate the Israelis. I hate their stupidity. They are going to tell the Jordanians and the Palestinians and the Syrians 'We will have peace!' They don't want you in the Middle East! You've taken away Jerusalem, which is important to them. You're going to give them Jerusalem? No! You're going to let all the Palestinians go back to their homeland? No! So what can you give them? Have you ever been to Gaza Strip? You walk into Gaza – go to a place called Jabaliya. I was in Jabaliya – the toilet is in the middle of the street! What do you expect from that?

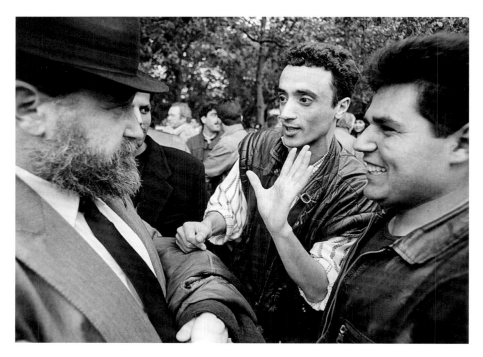

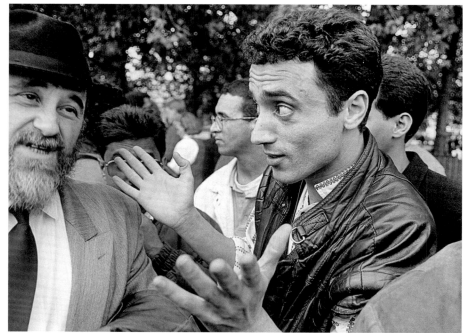

Argument, 1993.

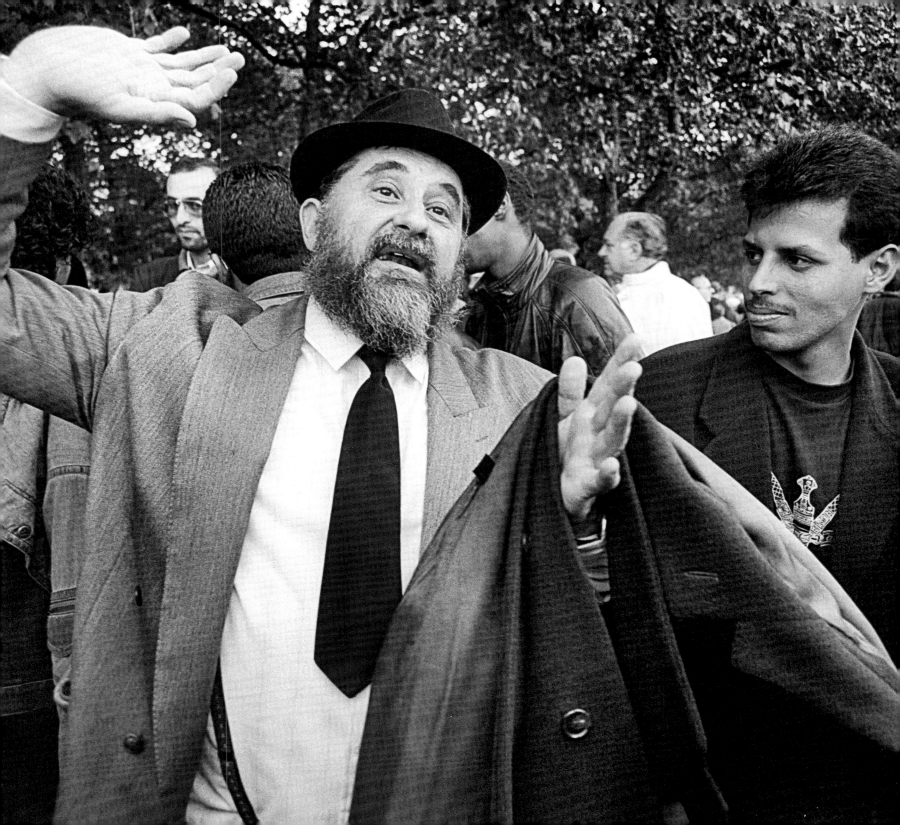

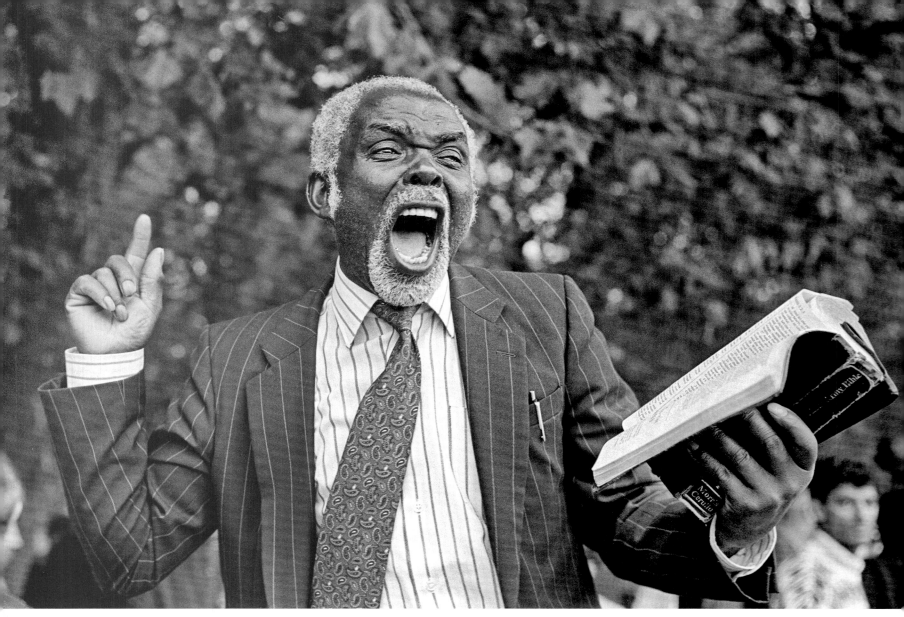

Christian preacher, 1993.

Speaker: Are you right with God?
Heckler: I'm not right with anybody!
Speaker: If you die tonight, where will your soul be?
Heckler: Kensal Rise cemetery – it's up that way.
Speaker: I want to tell you that your name must be written in the book of life. God has got a book up in Heaven.

Heckler: So have the police! They have a book as well!
Speaker: Whatever your name is, if you're born again, then you're going to get to Heaven.
Heckler: I don't want to be born again. Look what happened to me the first time.

Born-again preacher, 1993.

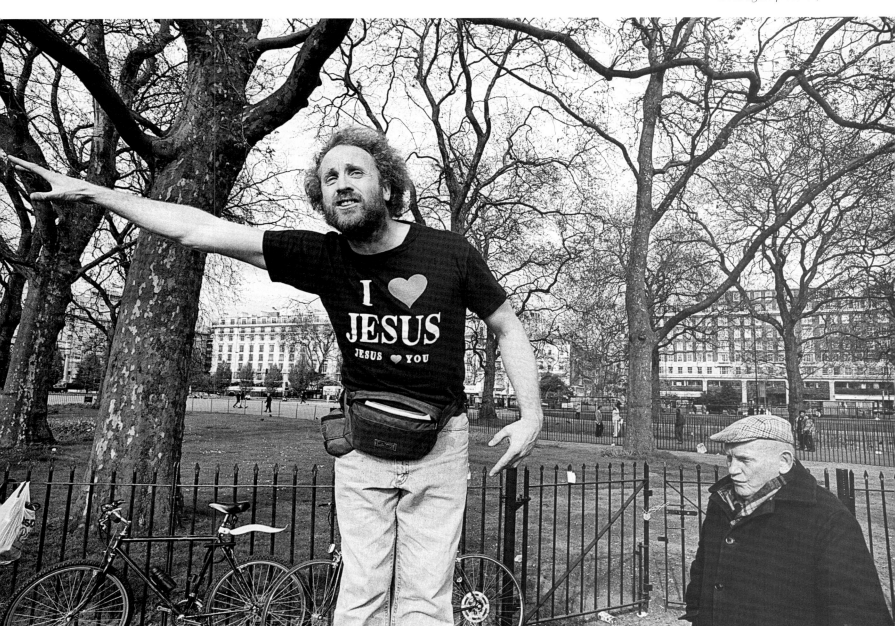

Abdurraheem Green: Take a good look at your democracy, your society, and your Western civilisation! Maybe you'll open your eyes. Maybe you'll see that the scientist who preaches atheism to you – maybe he's not so free from bias after all. Maybe he's just beating his own drum: the drum of materialism, the drum of the consumer society. 'There is no paradise. There is no hellfire. Just enjoy your life! Have a good time!' Well people, when you die you'll find out! I want you to think about death. Death is the reality. It's going to come and get you, people! The Angel of Death is going to come and get you. When you're in your grave the angel will ask, 'What was your religion? What was your way of life?' And you will say, screaming in pain, 'I don't know!' And the angel will say 'What did you think of this man – Mohammed?' And you will go 'Aaarrrgghh, aaarrgghh, I don't know! I don't know!'

Abdurraheem Green, 1993.

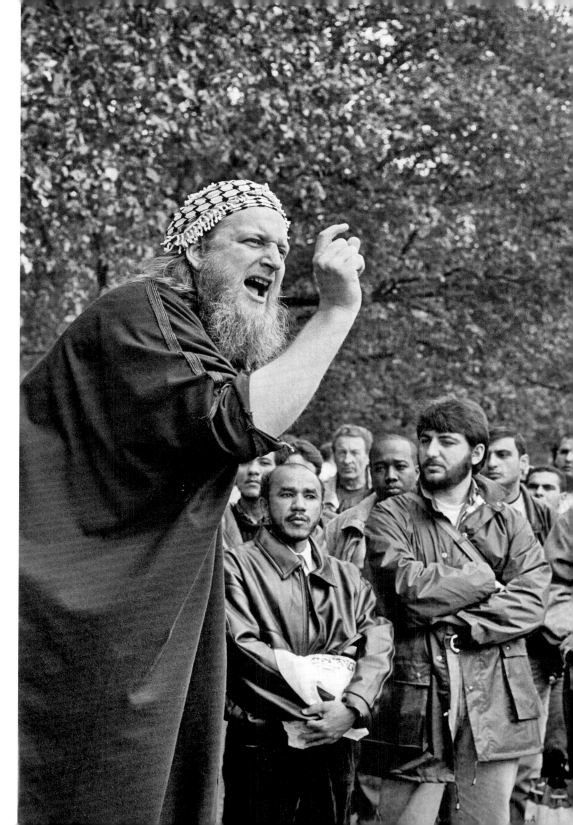

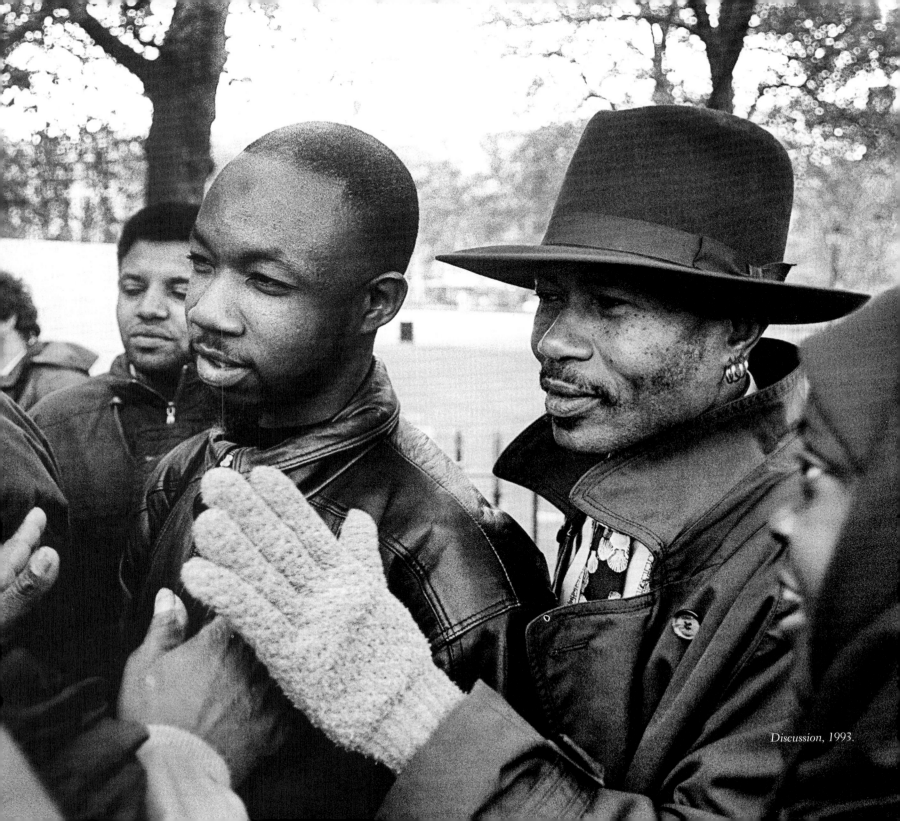

Discussion, 1993.

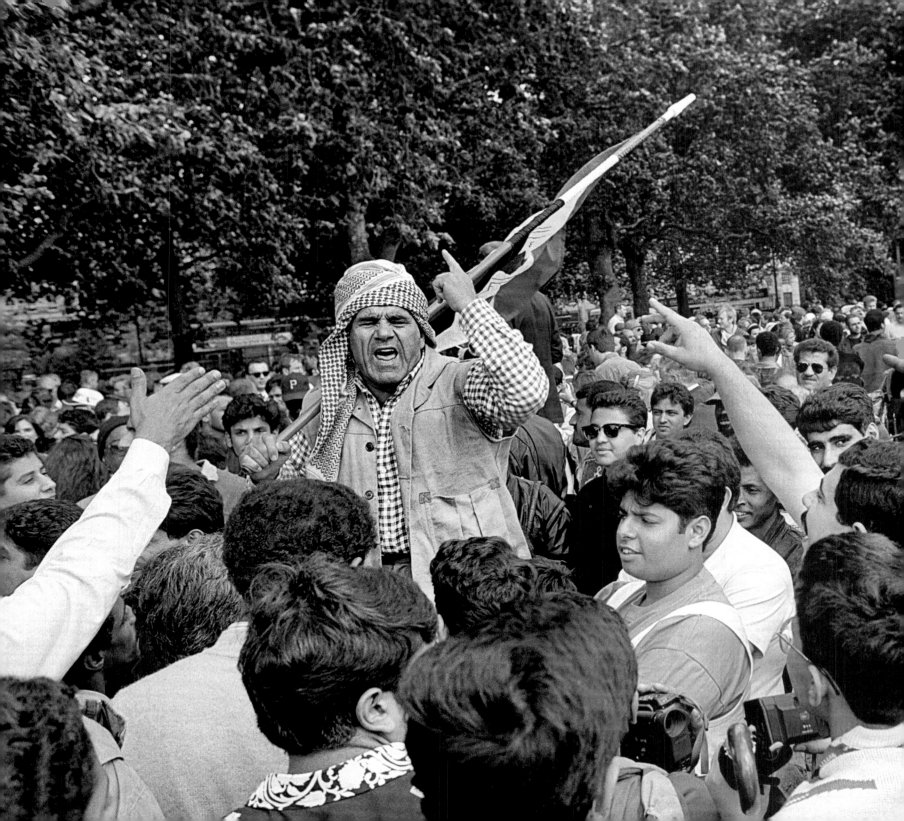

Speaker: Today, America [is] arranging to destroy any identity. They look in your skin; they look in your civilisation. Muslims, Islam, they don't want us. They forget how we gave them our civilisation. They forget that they learnt from us. They were blind, like animals, they don't know what to do. Even they don't know to wash the face, even they don't know to put [on] the clothes. They don't want to see the Muslims united. Because if we will be united, all those in America, all those who are still in power, they will be defeated and we will claim victory, ladies and gentlemen! Dear brothers and sisters! I want you to realise today we have no time to argue with each other! Today we must face our battle! We must face the name, our enemy American imperialism! The name, our enemy the Israel! We will be one power!

Pan-Arabist, 1993.

Preacher: Hear the Lord, all you sinners!

Heckler: You're an idiot!

Preacher: You're a pervert! I've read about you in the papers. This man is a known homosexual!

Heckler: I'm not a homosexual – I haven't got a home. I'm homeless!

American evangelist, 1993.

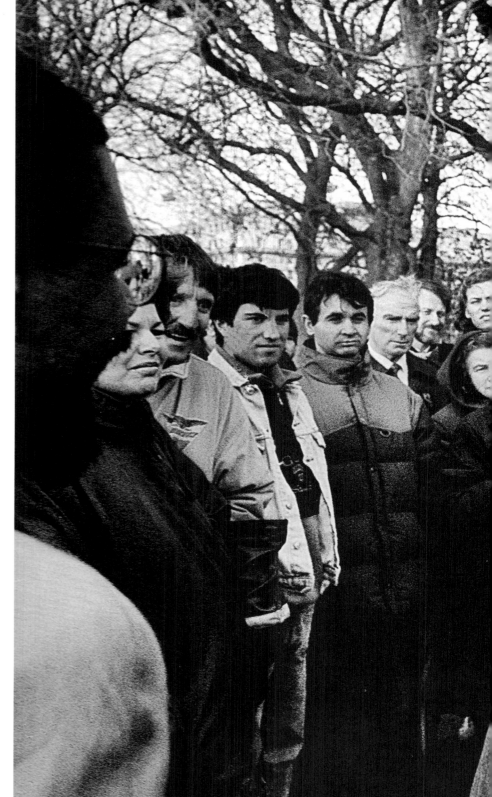

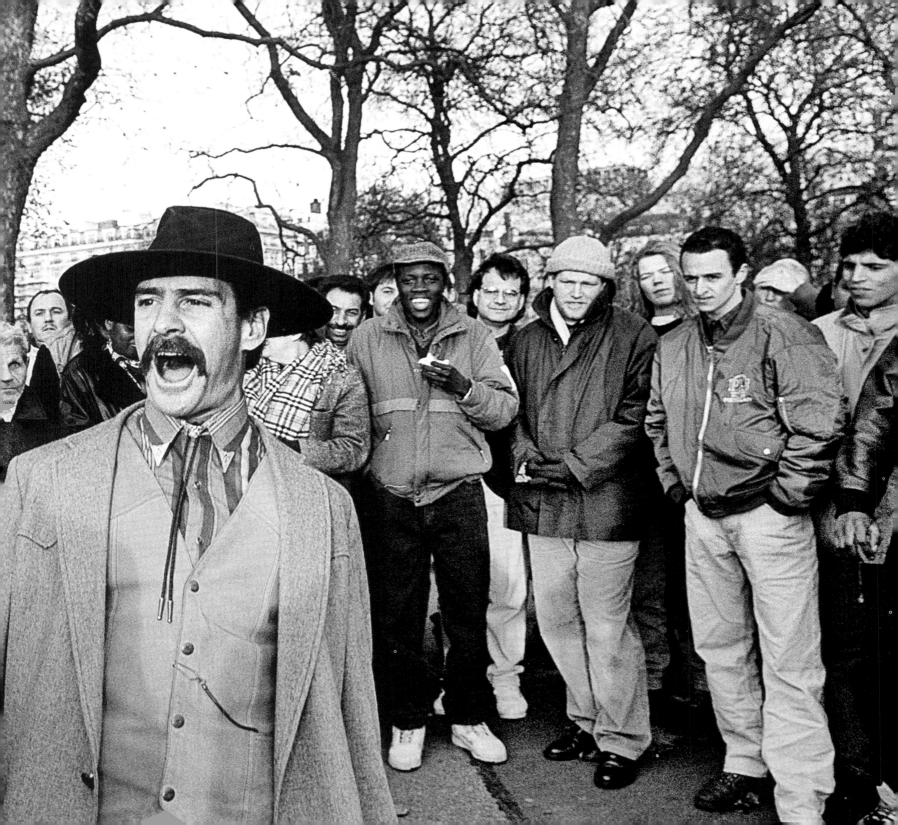

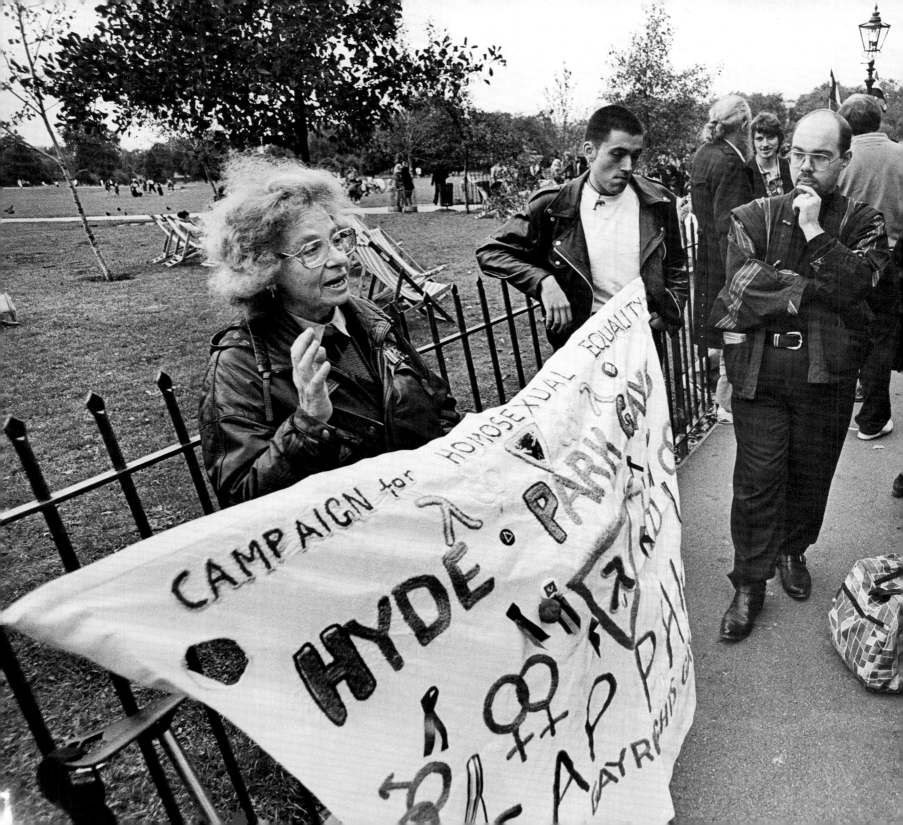

Sharley McLean, Hyde Park Gay and Sapphic Society, 1994.

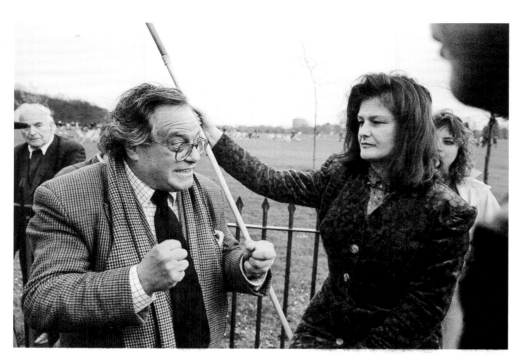

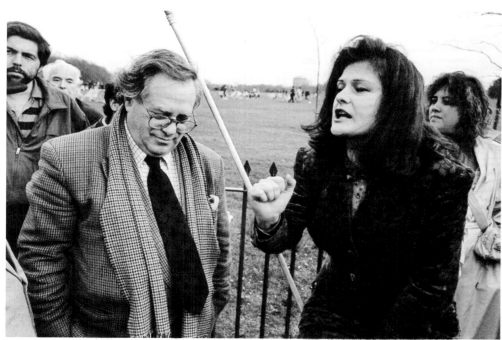

Argument, 1993.

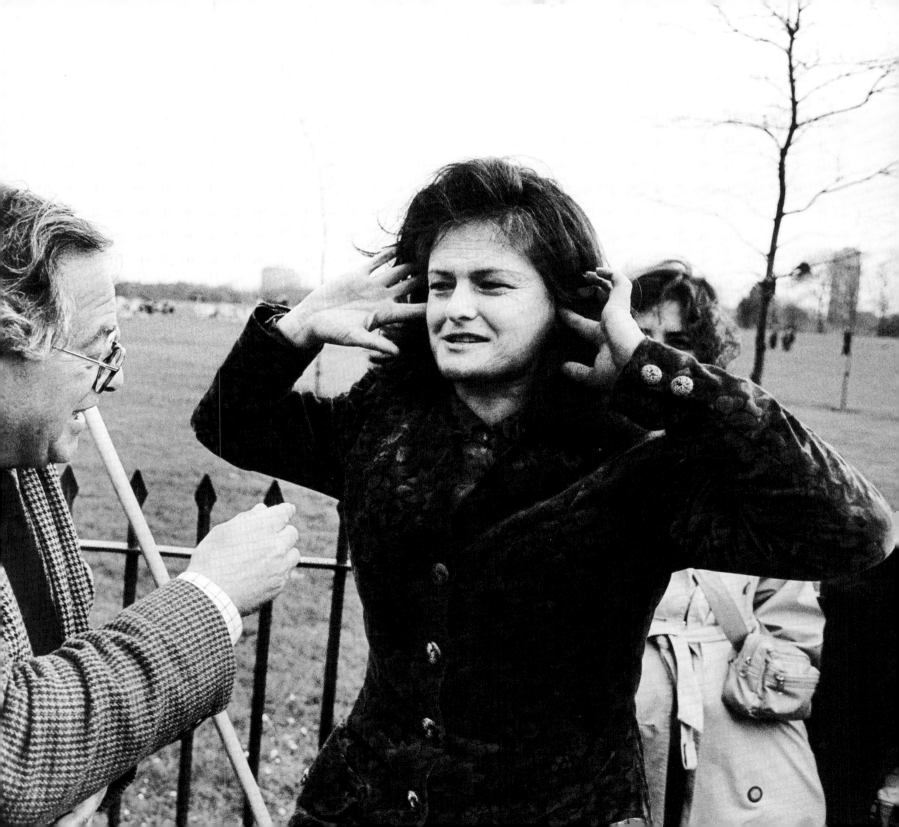

Preacher, 1993.

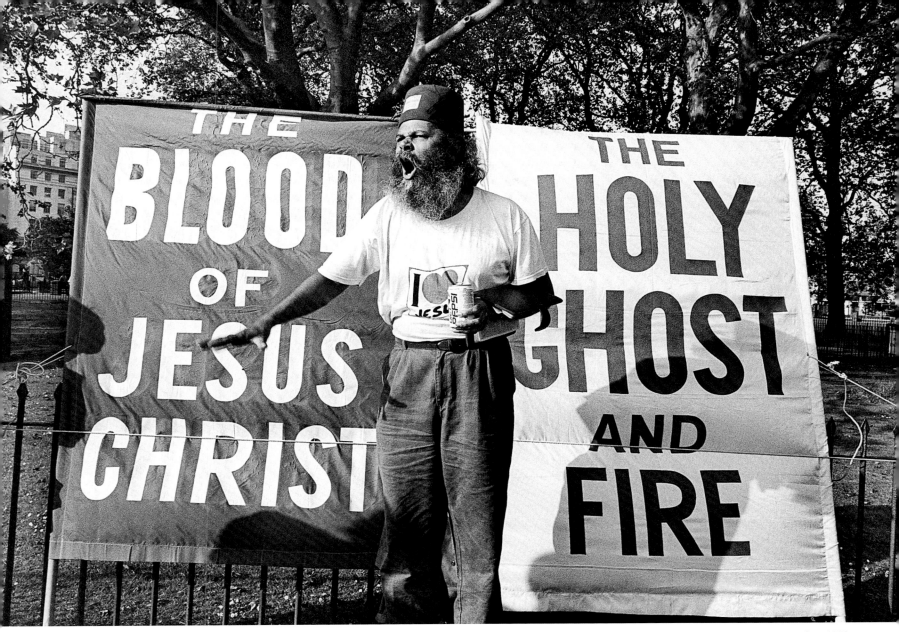

Preacher, 1993.

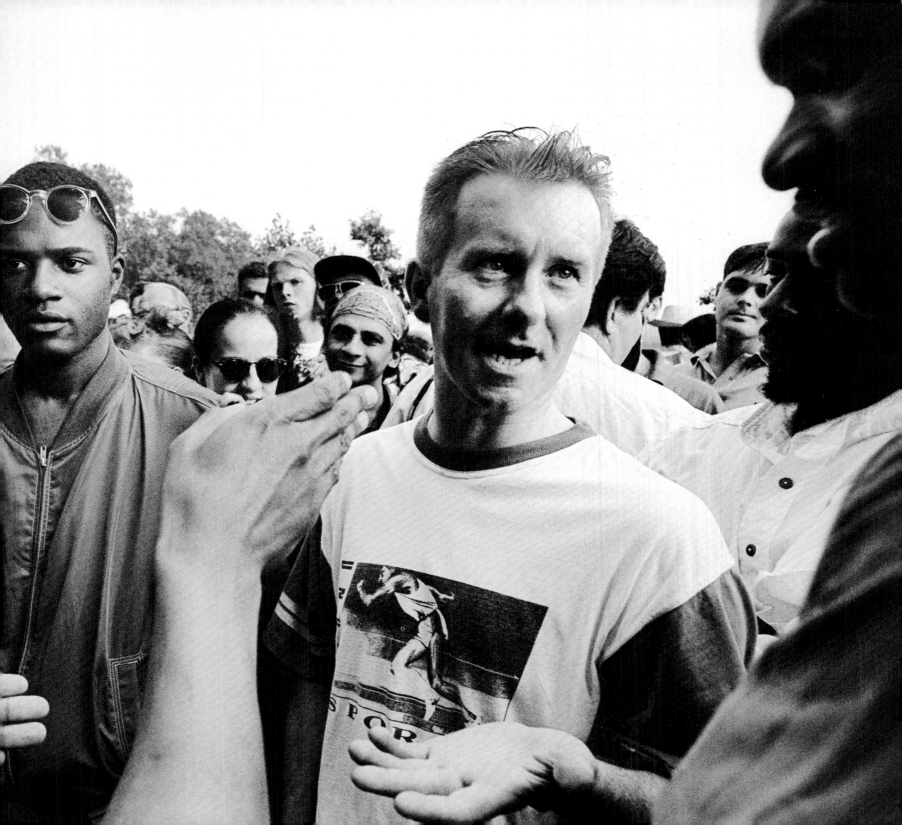

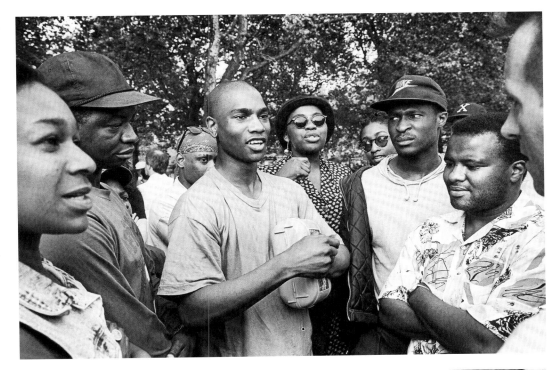

White man: You say you feel oppressed here. I've got black friends who like being with white people. They're happy here. If being here makes you so angry, why don't you go home, for your own good?

Black man: Why should I go anywhere? I was born here. It's you white people that are the problem. You white people have no identity, you are not a race. You are nothing!

White man: But it's you who says you are African, that you belong in Africa. If it's so bad for you here, why don't you go to where you say you belong?

Crowd: Racist! Racist!

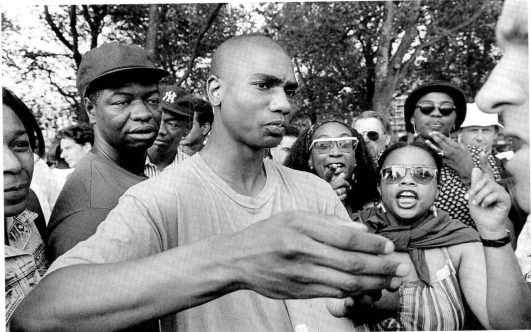

Argument, 1993.

Speaker: Hey! This guy's studied African history! Can you imagine that? A white man studying African history!

Black bystander: Don't listen to him. What can a white man know about Africa? All they know about is how to exploit black people!

Speaker: Wait, wait! Let me ask you – have you read Du Bois? Have you read C.L.R. James?

White bystander: No, I haven't read them.

Speaker: You haven't read C.L.R. James and yet you call yourself a student of African history! Tell me, where did you study your African history? Was it at the School of Oriental and African Studies?

White bystander: No, I went to Lancaster University.

Second black bystander: Lancaster University! So you come from up north?

White bystander: No, I come from Essex.

Second black bystander: Hey! He comes from Essex! And to study African history he goes to Lancaster! He carefully skirts Brixton, goes past Brunel, steers well clear of Birmingham and Bradford! He even misses Liverpool! And he goes to study Africa at Lancaster University!

Black bystander: Don't listen to him. He's a white man. He doesn't know anything!

Speaker: Wait a minute, wait a minute. Tell me my friend, what are you going to do with all your studying?

White bystander: I'm a teacher. If white children learn more about black people's history, then there will be more understanding and less racism. For instance, I teach my class about people like Mary Seacole. Everyone knows about Florence Nightingale, but how many people know that Mary Seacole, a black woman, also went to Crimea? A real nursing pioneer, just as important as Florence Nightingale!

Speaker: Hey! This guy knows his stuff! Be careful, you'll become alienated from white people if you carry on like this!'

Second black bystander: No, no, don't worry, he still can't dance!

Discussion, 1993.

Heckler, 1993.

Heckler: They didn't know how to navigate before they met a black man! If it wasn't for the stupid Egyptians, they wouldn't have got educated. If it wasn't for the Egyptians they would still be ignorant! The black man has always built, he has never done anything but build. White people have always destroyed, and bombed and killed!

Speaker: The idea about black and white is stupid!

Heckler: We're not talking about black and white, we're talking about African and European history. You're telling us the white man is cleverer than us. The white man isn't cleverer than the black man! Everything the white man knows is because of the black man! Their history only goes back a thousand years. Our history goes back tens of thousands of years. We are the superior race because we are the makers of the world!

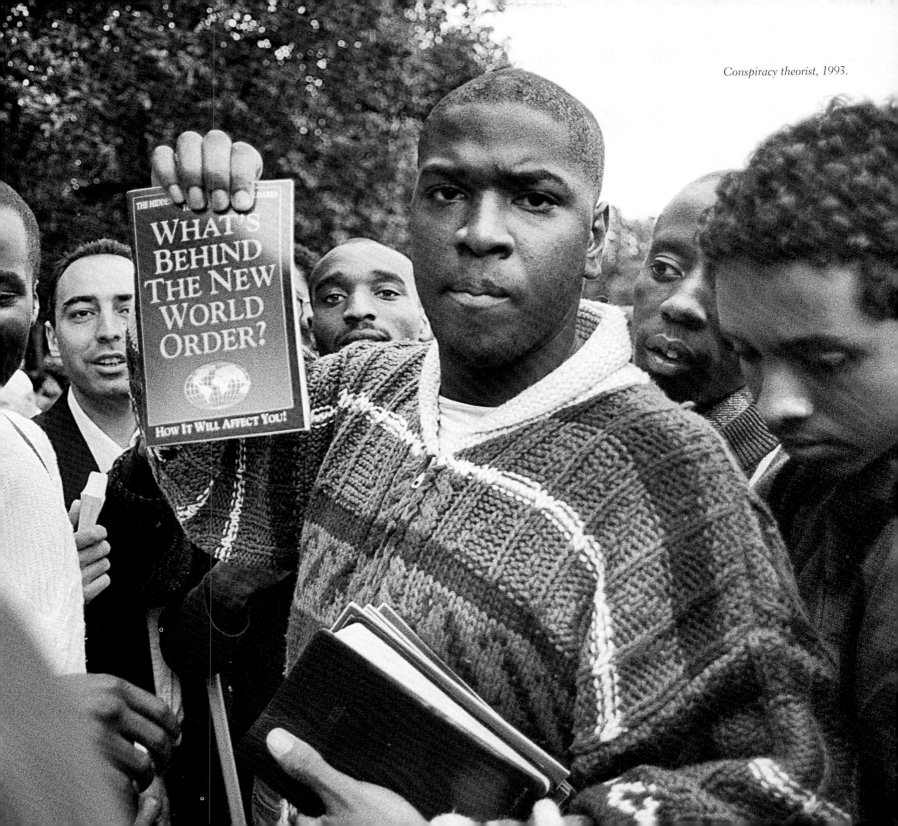

Conspiracy theorist, 1993.

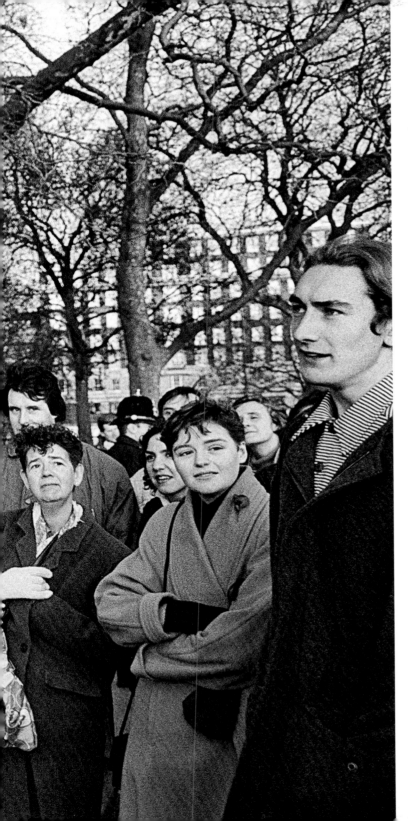

Speaker: I'm fighting a three-minute attention span. It would take me three hours to expound my world view, and even then you wouldn't have it in its entirety. But you want fast food. You use me like a sort of outdoor television. You stand there for a few minutes, then you switch channels – you wander off to see what else you can find.

Heckler: Can I ask you a question?

Speaker: When you say, 'Can I ask you a question?', you've already asked me a question, haven't you?

Heckler: OK! So tell us your world view. Tell us — what is the meaning of life?

Speaker: Don't go round asking questions like, 'What is the meaning of life?' That's the way you cause religions!

Public philosopher, 1993.

Bobby Beckford: How do I know Jesus was black? Well, listen my friend, he was a very talented man, right? He had many skills, he could do miracles, right? And yet he still couldn't get a proper job! So of course – he must have been black!

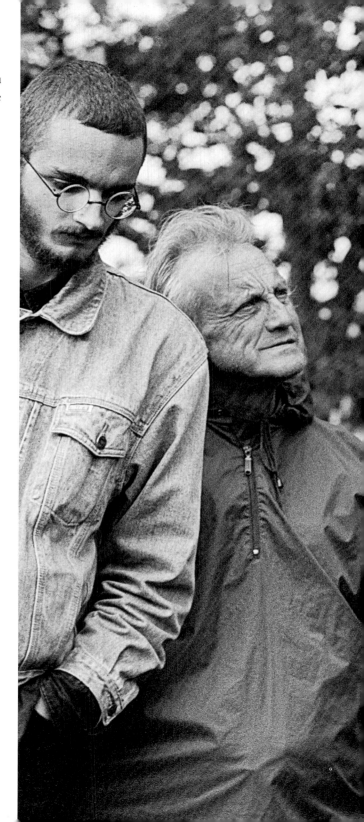

Bobby Beckford, 1995.

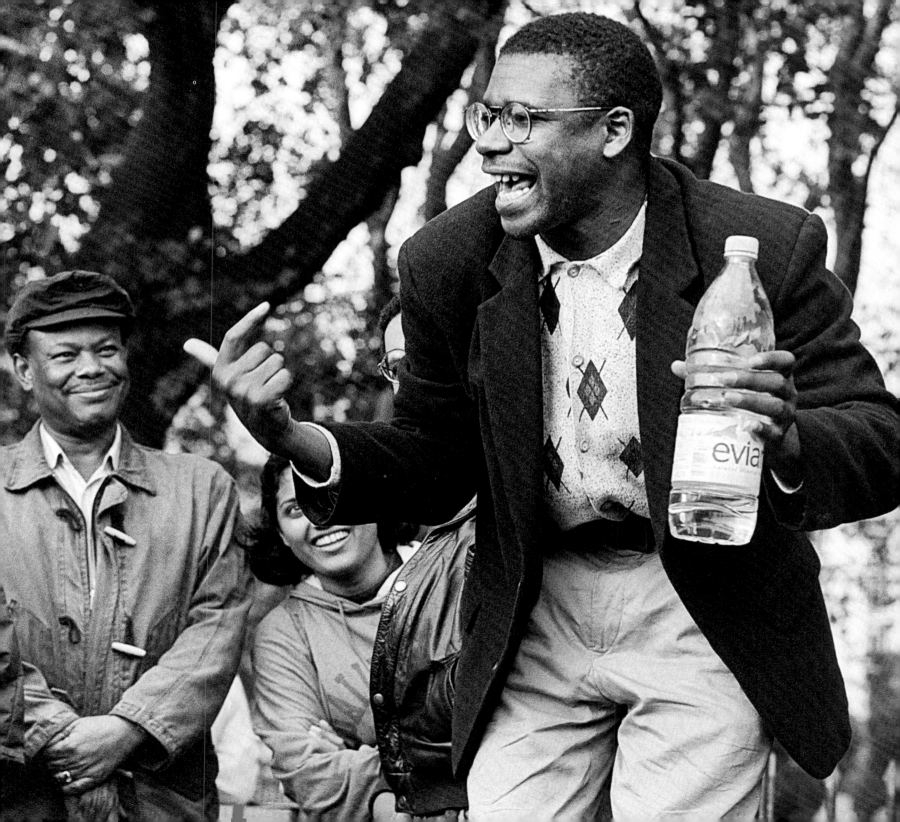

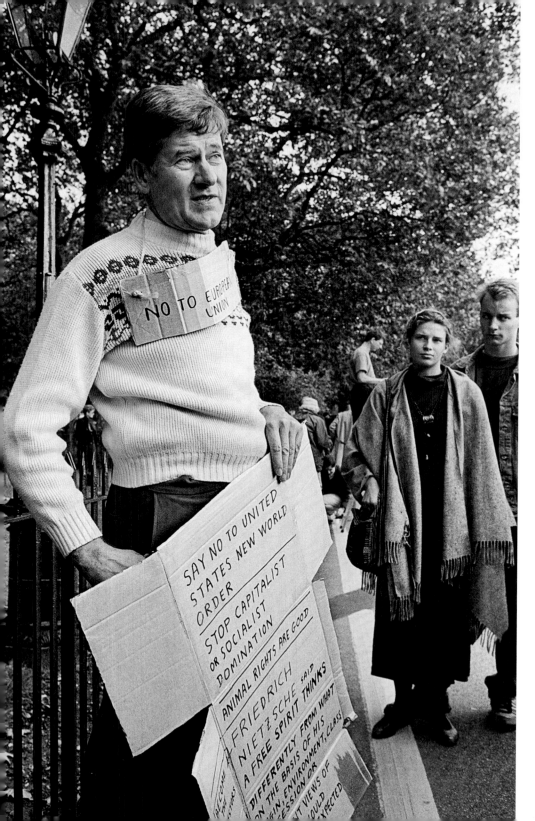

Speaker: The people who control this country – why do you think they let in all the immigrants and refugees? To make Britain a multi-racial society, so that they can control the mass of the people! The top people are closing factories in England and America and moving them to China and Mexico. There's no crisis in capitalism! They know what they're doing. If you speak to anyone in the Western world that's interested in politics and who's not controlled, they'll tell you. Ninety-eight per cent of the population is ignorant. They're controlled. Everything that goes on in the world today is set up. Judaism, Christianity and Islam are all mind-control mechanisms set up by the intelligence services of the world.

Bystander: OK, so there's an international conspiracy – what are we supposed to do about it?

Speaker: You have to join a party that stands for national sovereignty. You have two alternatives in the next fifty years. Either an international elite running the world, or a national elite. There's either nationalism or internationalism. There's no third way. The international elite that control everything under the New World Order are not interested in the survival of the English working class. The only thing that threatens the international Masonic groups which control the New World Order is nationalism.

Bystander: What party do you support then?

Speaker: Me? I don't have to support a political party, I'm a speaker at Speakers' Corner.

Conspiracy theorist, 1993.

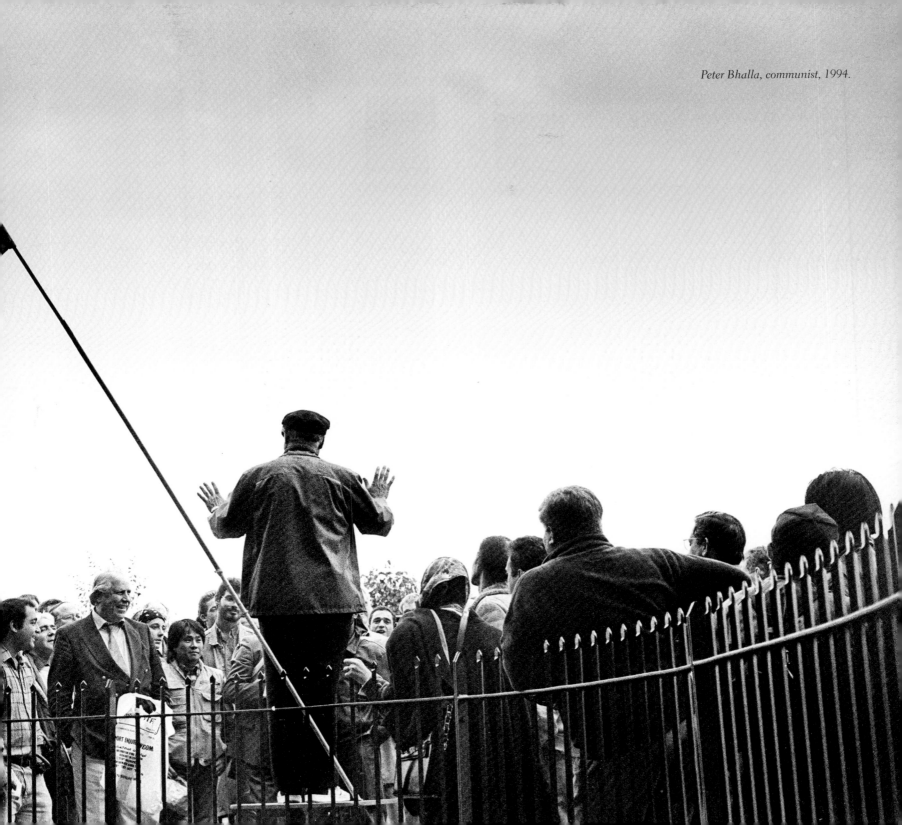

Peter Bhalla, communist, 1994.

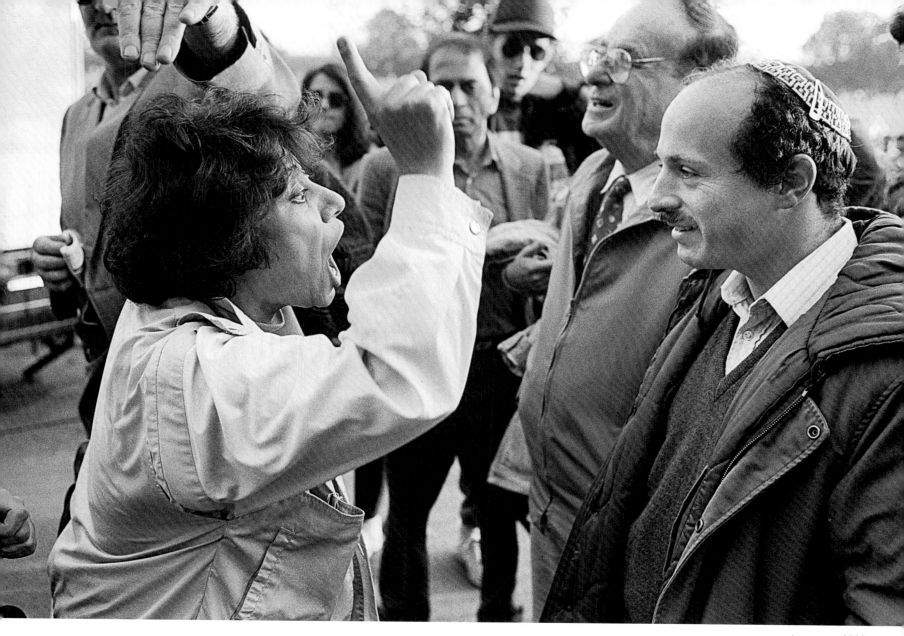

Argument, 1993.

Iranian Woman: Respect and dignity was among people until the Jew-Arab, the so-called Jew, came and destroyed the world. The government is Jew-Arab! Why are people afraid of talking about the Jew? Why? Because the <u>Queen</u> is a Jew! That's why they are afraid of talk about the Jew! They can't fool [the] Aryan race! They will be finished! Soon!

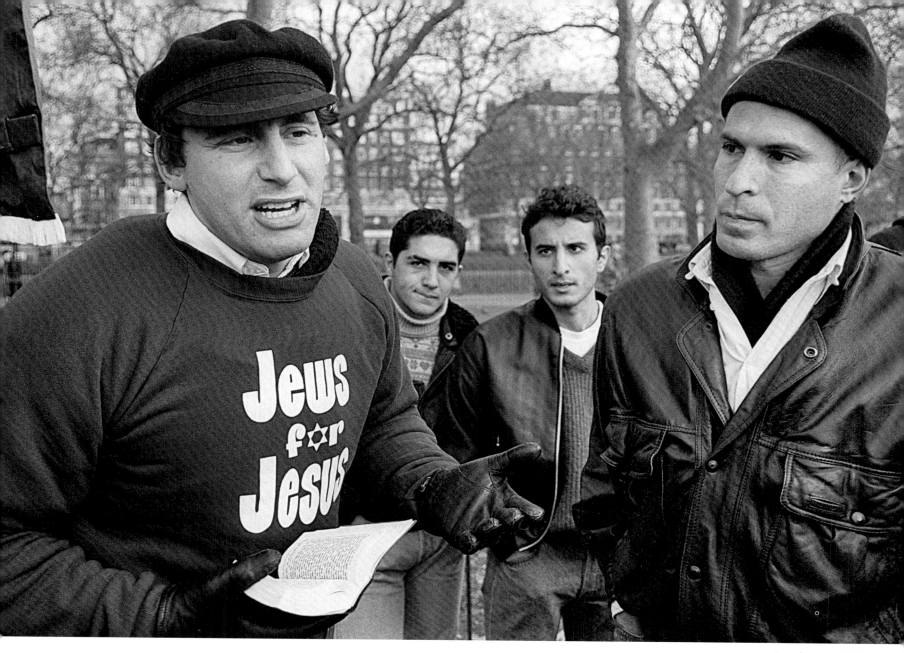

Jews for Jesus, 1994.

Heckler: If you are a Christian, why don't you have a cross instead of that Star of David?
Jews for Jesus: Why don't I carry a cross? Because the cross for me is a sign of persecution – it's as bad as the swastika!

Heckler: Well, what are you, a Jew or a Christian?
Jews for Jesus: You don't like it do you? You have a problem with me, you can't categorise me. I'm a Messianic Jew. I'm a Jew that accepts Jesus as the Messiah.

Bystander: They drink the blood of children. They dip the matzos in the blood of children. They cook the matzos to dip them in the blood. Not the bagels. So now many countries stop them cooking matzos. They tell them: 'We don't mind you cooking bagels. But no matzos. You can cook as many bagels as you like, and those jam rolls. But no matzos!'

Jewish man celebrating Purim, 1993.

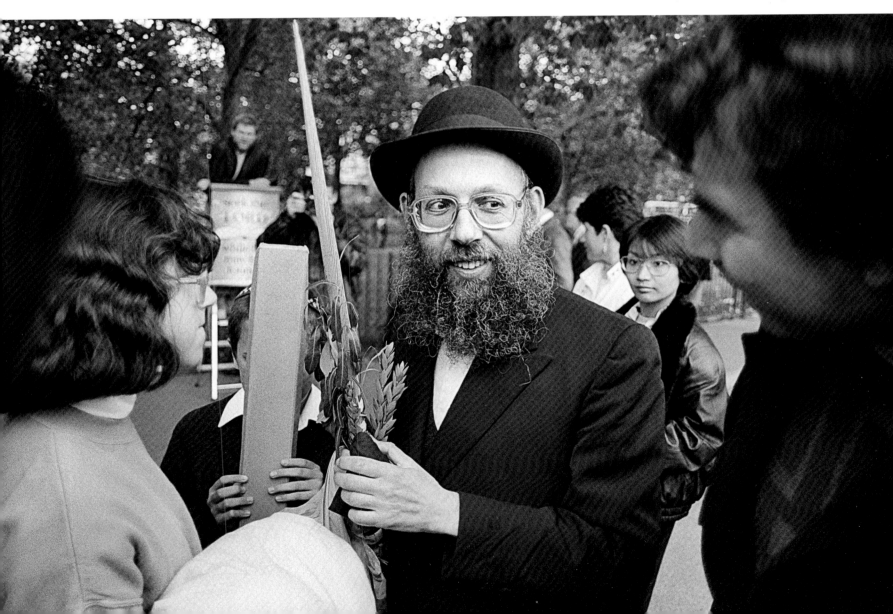

Woman in crowd: Why is there inequality between men and women?

Ali: Why is there inequality between the genders? OK, let's look at this problem. Now who are you? Are you a woman? What gender are you?

Woman in crowd: I'm female.

Ali: Female is not a gender. You are talking sex.

Woman in crowd: I am not talking sex.

Ali: You are, you said you're female. Being female is not the same as being a woman. When we speak of sex we speak of being male and female. When we speak of sex we talk about the body – biology. I am not discussing your biology or your body.

Woman in crowd: Neither am I.

Ali: Good, good. So forget being female, right. If I were a doctor I would talk about your body and your sex. I am not. Besides it's against the law. I use gender because I know gender is problematic, because with gender we mean culture, society, history. You say you are female, but I don't know, I have no evidence. If I was to use as evidence the clothes you wear, I could say you dress like a man. You wear trousers like a man. You wear a jacket like a man. How do I know if you're a female? Some male transvestites dress better than some women.

Woman in crowd: Most men dress better than you! You've got a whole crowd listening to you, you should be telling them something useful instead of making jokes. Do you have to make jokes out of everything?

Ali: It's got to be a joke, ladies and gentlemen, it's got to be a joke that women are inferior to men! Because the only people who take this thing seriously are psychopaths and male chauvinists. It's not morally acceptable that more than half of humanity should experience this nonsense. So it's got to be a joke, because tyrants do not like laughter. And the only way to liberate women from the tyranny of patriarchy is to laugh, to take the mickey out of it. In that way you deconstruct this fascist authoritarianism. It's a bloody joke!

Ali 'The Professor', 1993.

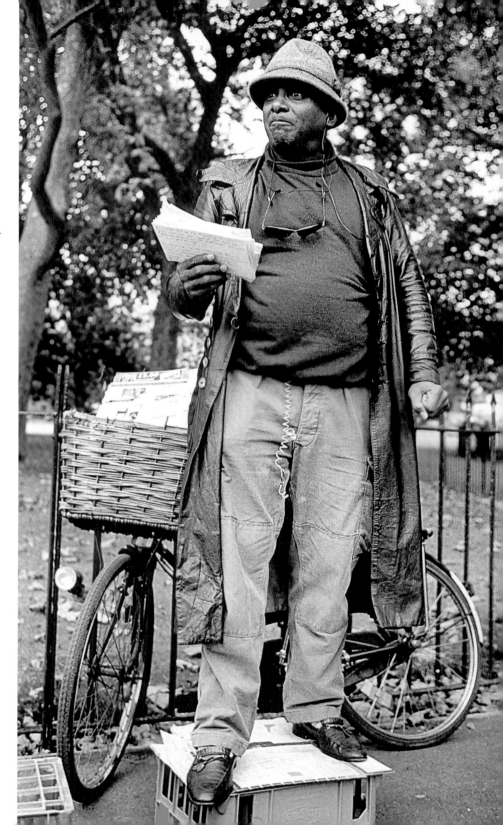

Peter: I'm an atheist. For me, the Christian faith is of human origin. I'm a follower of the man Jesus Christ because of his message, which was that justice was first – that great vision, of peace on earth. The Kingdom of Heaven is at hand: the blind see, the lame walk, there is an end to oppression. That vision can only be accomplished through human effort. A belief in God obstructs that vision.

Peter, Christian Atheist, 1993.

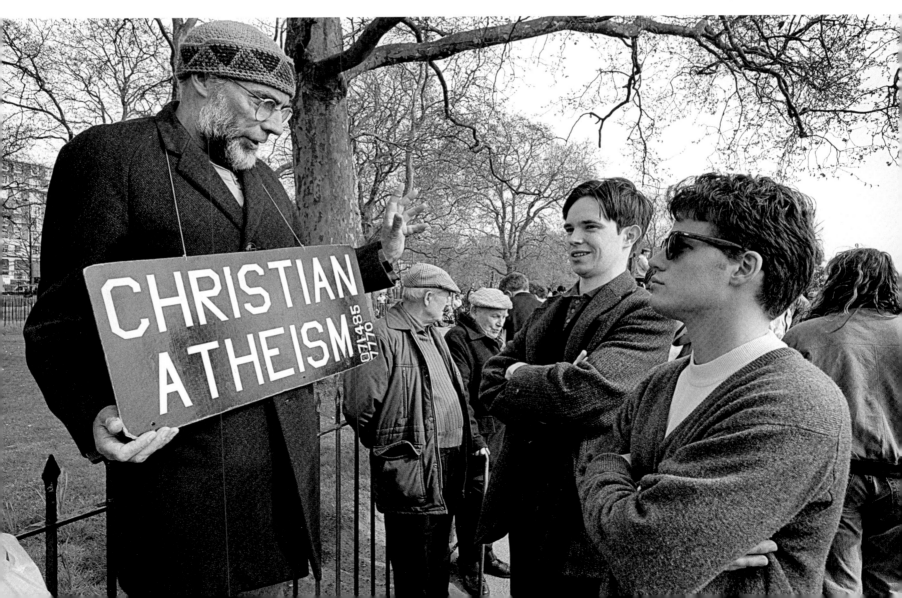

Preacher: Adam and Eve were physical people, so they had to live in a physical garden. A lot of people laugh at it today, but you know them four rivers are still there. It's down the south of Assyria and north of Babylonia. That's where the Garden of Eden is. They were cast out. They lost the Glory of God. God didn't want them. So he quickly put a cherub in there with a two-edged sword, so they wouldn't have access. They were cast out of the presence of God, the Garden of God, which is Eden. But anyway, at the end of the day, God respects everybody's free will, and it's up to us what we believe in.

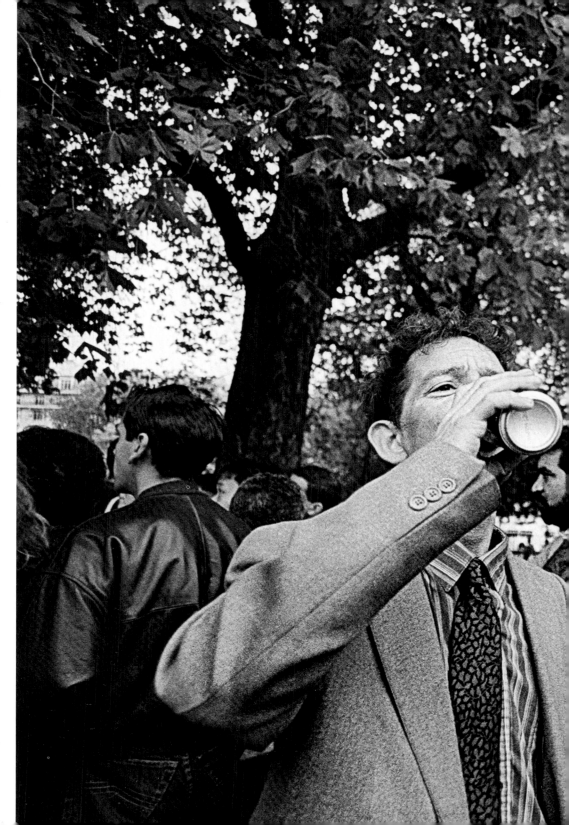

Preacher, 1993.

80

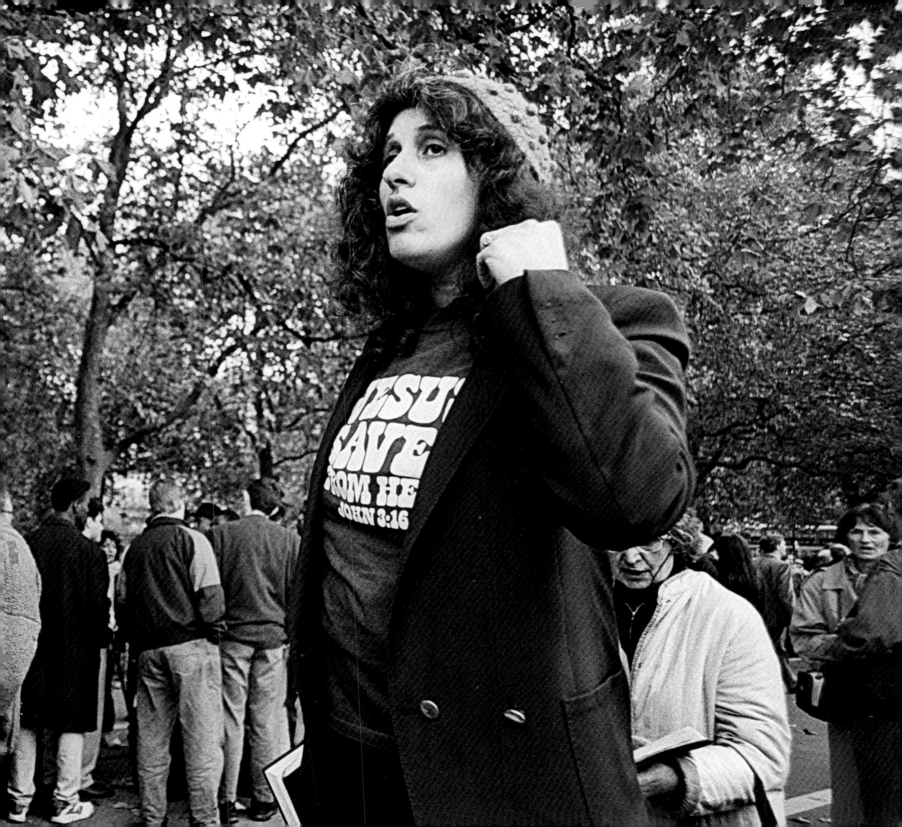

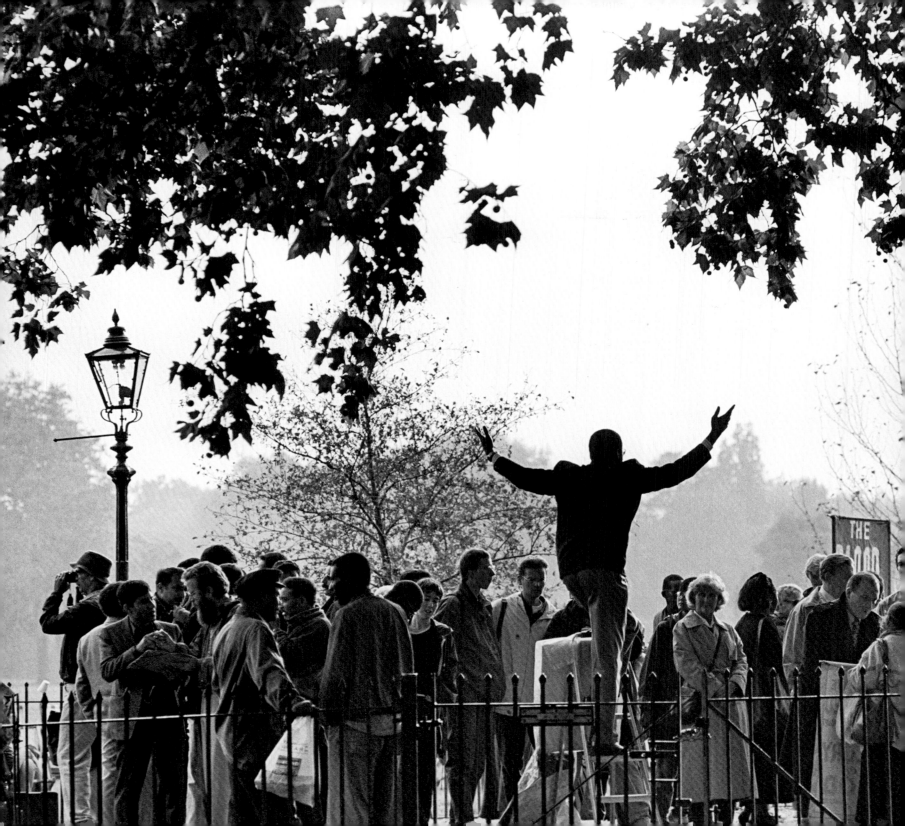

Christian preacher, 1995.

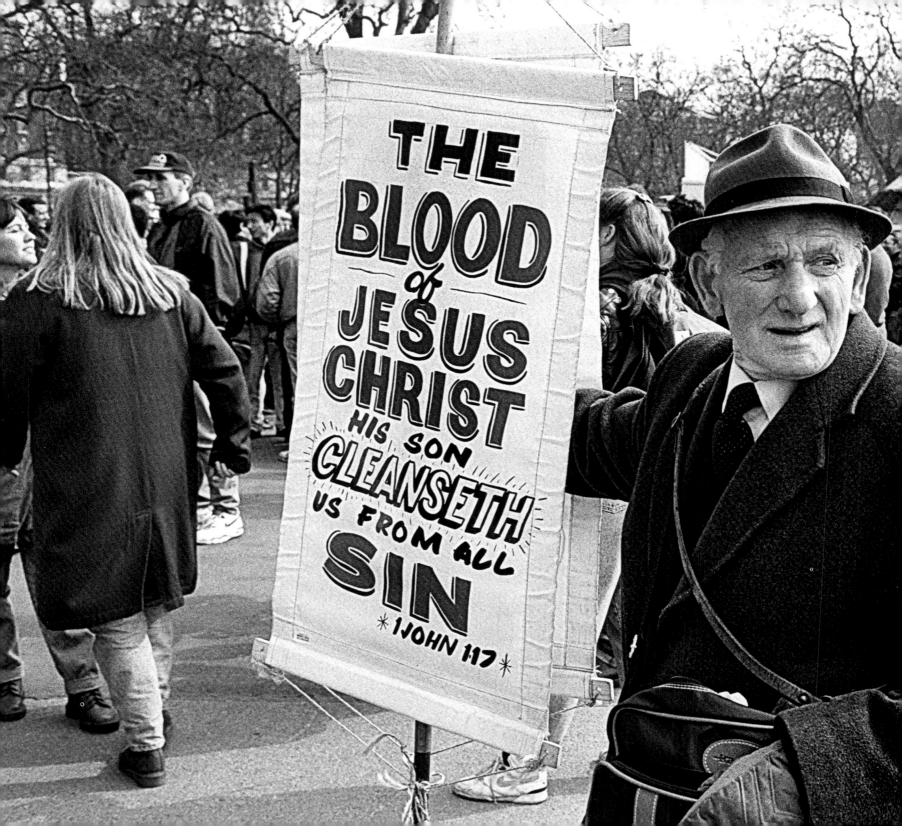

Evangelist, 1993.

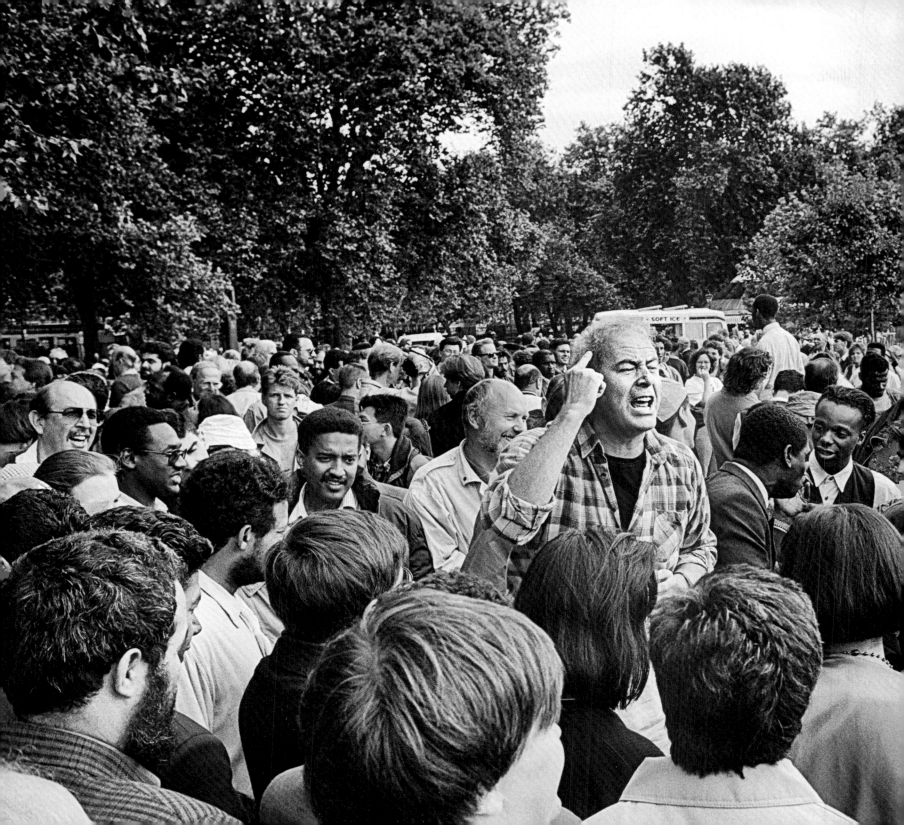

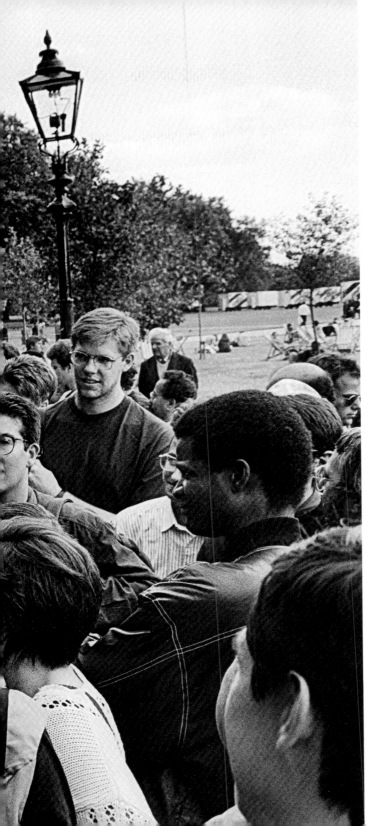

Barry Roberts: Heraclitus, Plato and Neitzsche – I quote them a lot. They're my favourite philosophers. They're all into dialectical opposites. How can you know Allah unless you are at one with Allah? How can you know Jesus unless you are at one with God? You must cultivate detachment. At the root of what we are is the absolute, the God, the One, Nirvana!

Barry Roberts, 1993.

Simon 'Doctor Bulgaria', 1993.

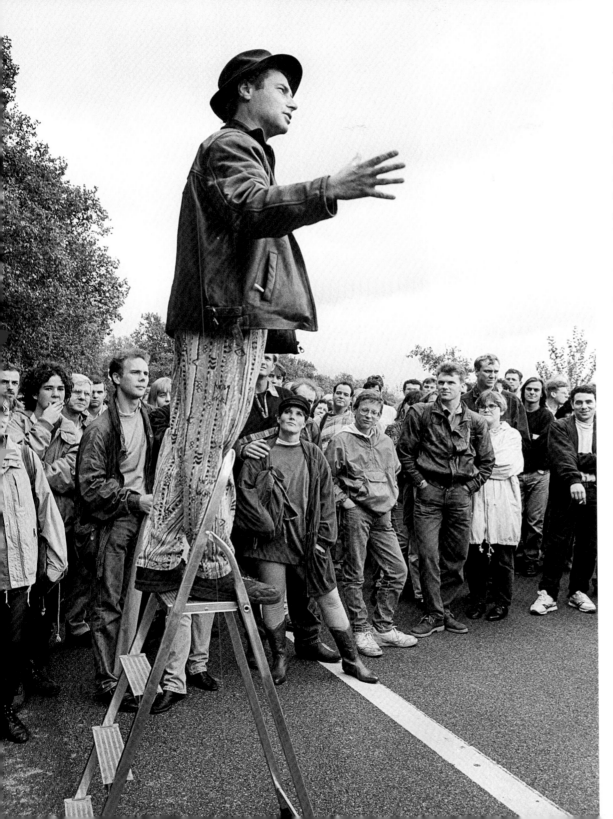

Martin Besserman: We men are more considerate; we are more loving; we are more sensitive; we are more giving; we are more caring; we are better than women! Can anyone argue with that? Women! I'm not anti-women! I'm just recognising their characteristics: they are not principled; they are bitchy; they are manipulative. If they get a better man than the one they are with, they will not think twice. Do you know how many women have been married and are in a steady relationship and have come to me and said, 'Martin! I want you!'? I'm serious! This is the reality. Look at the lady standing nearer to me than any other woman! I've been watching your movements. You like me, don't you!

Martin Besserman, 1993.

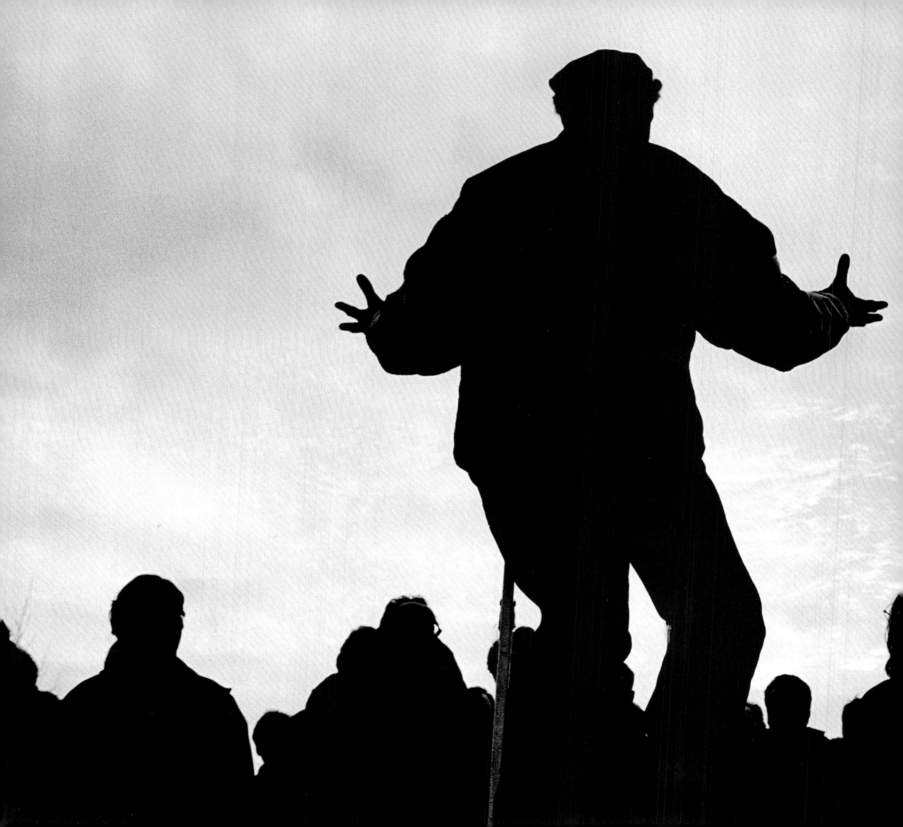

Martin Besserman, 1996.

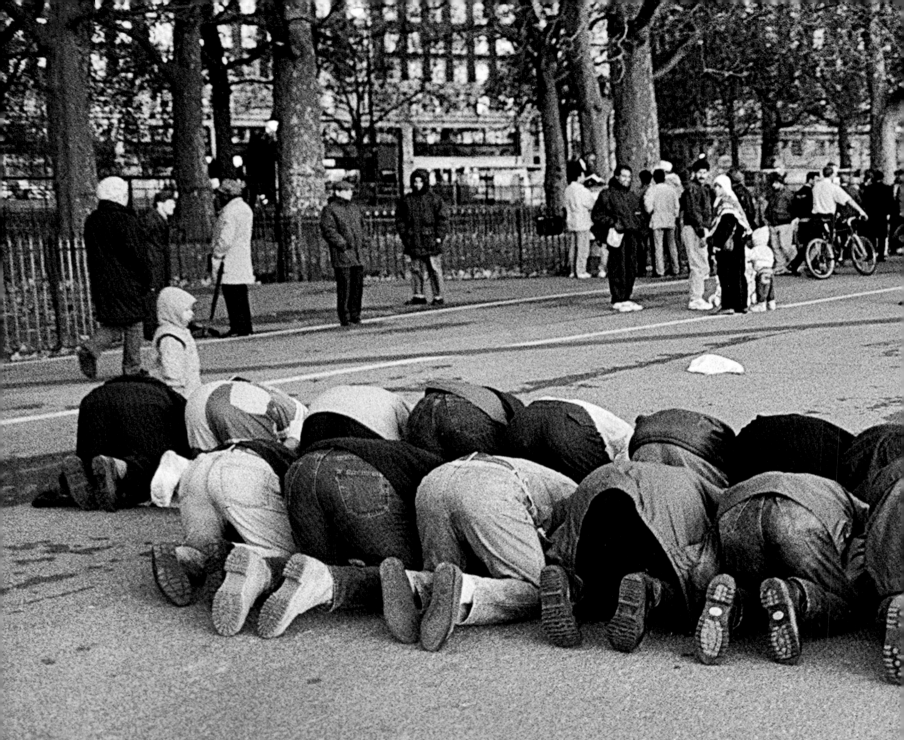

Muslim prayers at dusk, 1993.

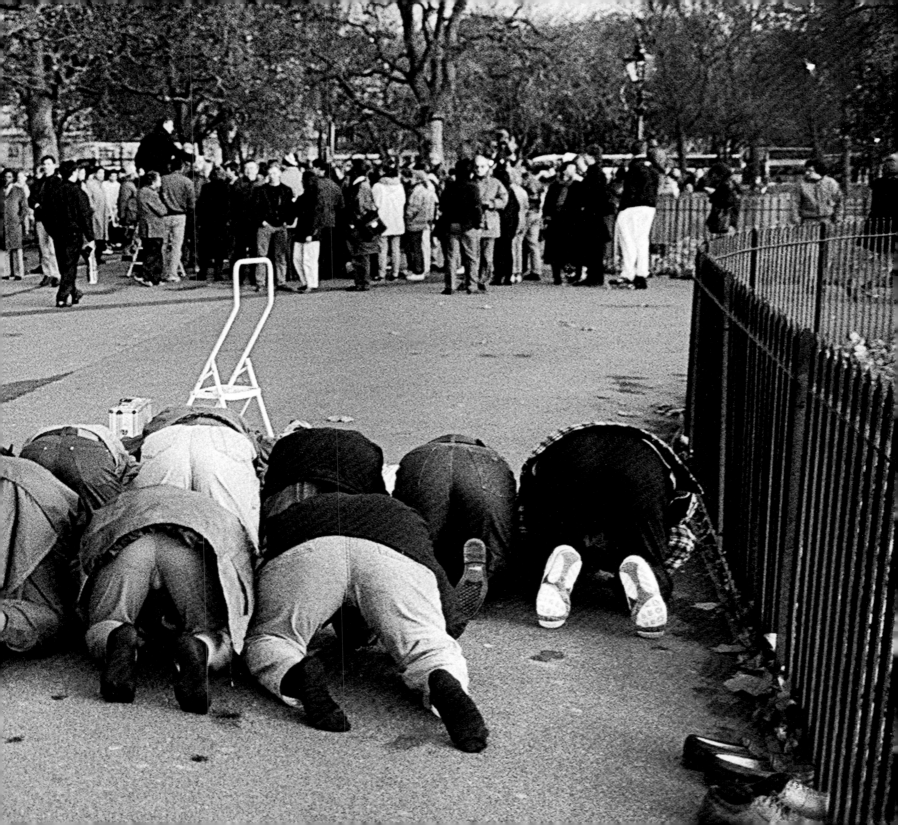

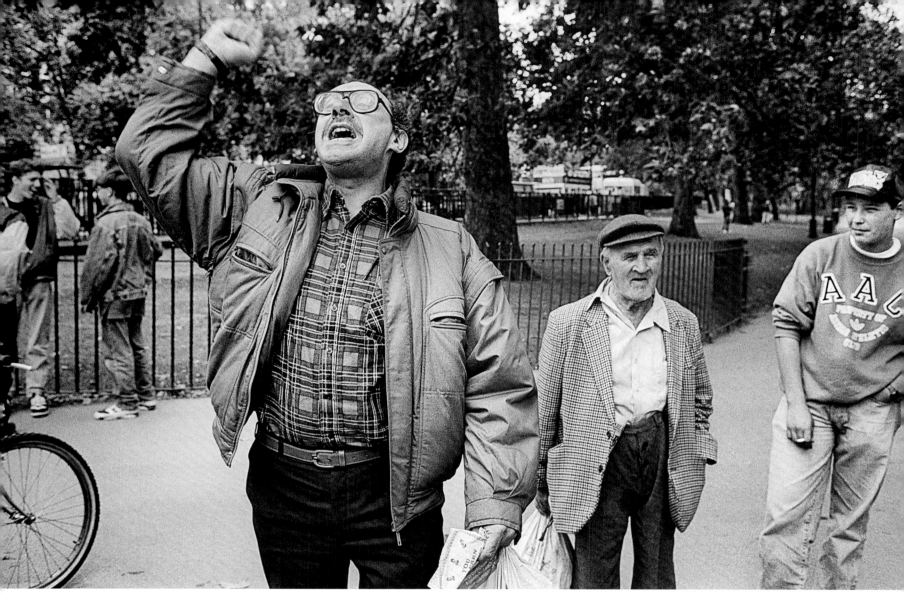

Casey, 1993.

Casey: The Israeli Government has to clamp down on the terrorists in the Middle East! The Arabs don't care if they get killed when they kill Israelis. They think they are going to paradise! They don't go to paradise, my friend! You know where they go? Paddington! That's where they go!

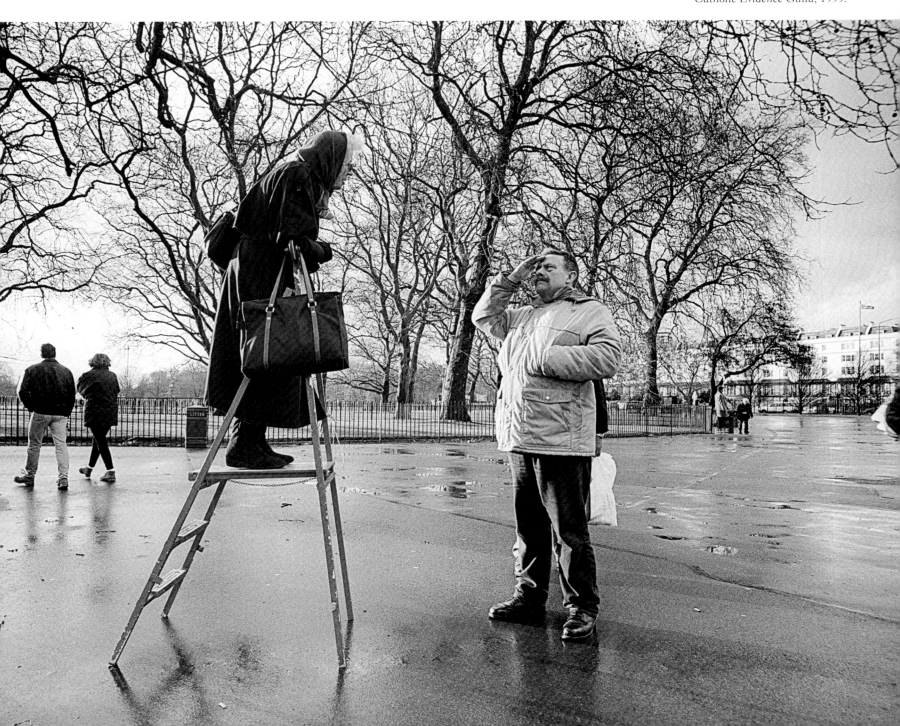

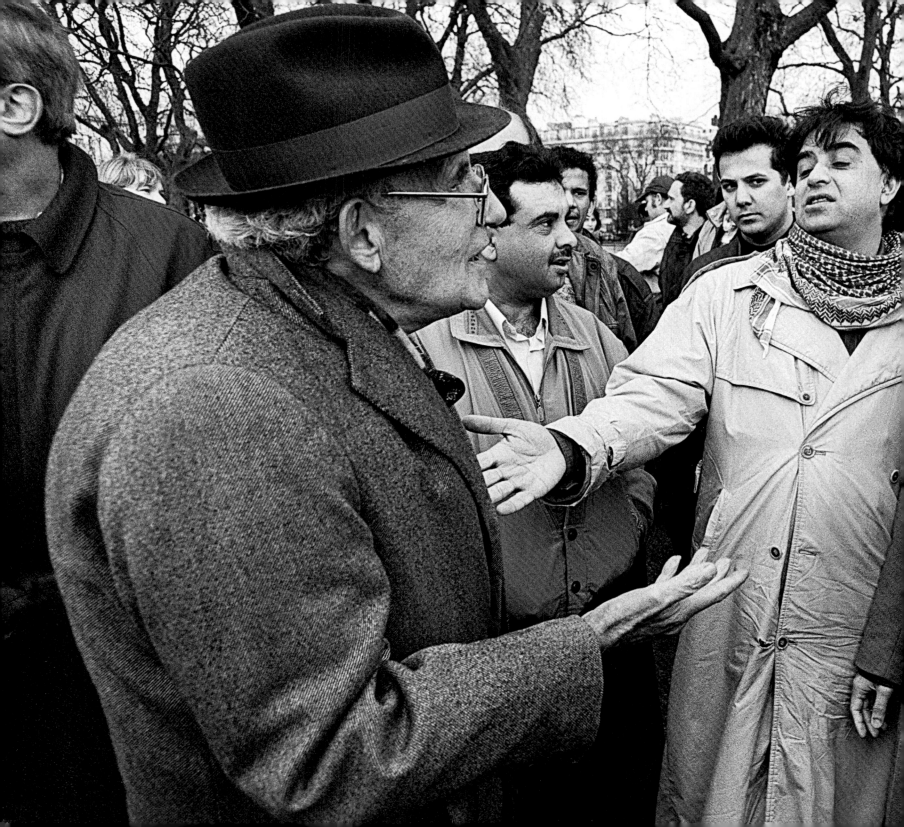

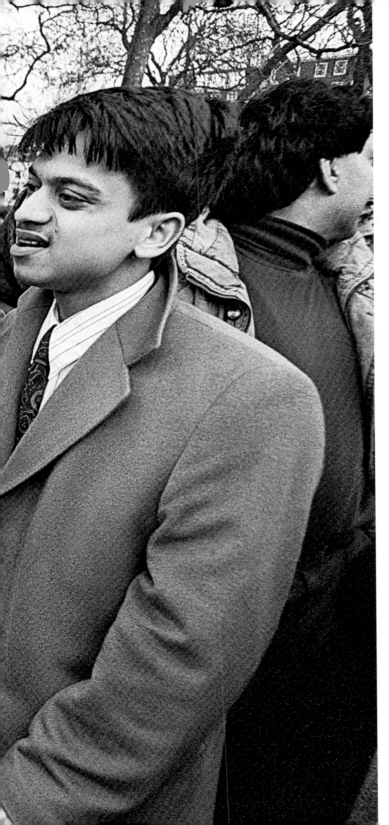

Muslim: Why do you come here every week saying the same things?

Christian: To annoy you Muslims. I am only defending myself. It says in the Koran that as an unbeliever I will go to Hell and I will burn and lose one skin, and then another skin, and then another.

Second Muslim: Yes! Yes! That's right! And you say, 'God is the Son, God is the Father and God is the Holy Spirit'! Three Gods! Buy one, get two free? There is only one God – Allah!

Christian: I think you are disgusting! You come over here to vilify Christianity.

Muslim: You have prejudice in you!

Second Muslim: You are stupid old man. Soon you will die. Alone with your dog!

Argument, 1995.

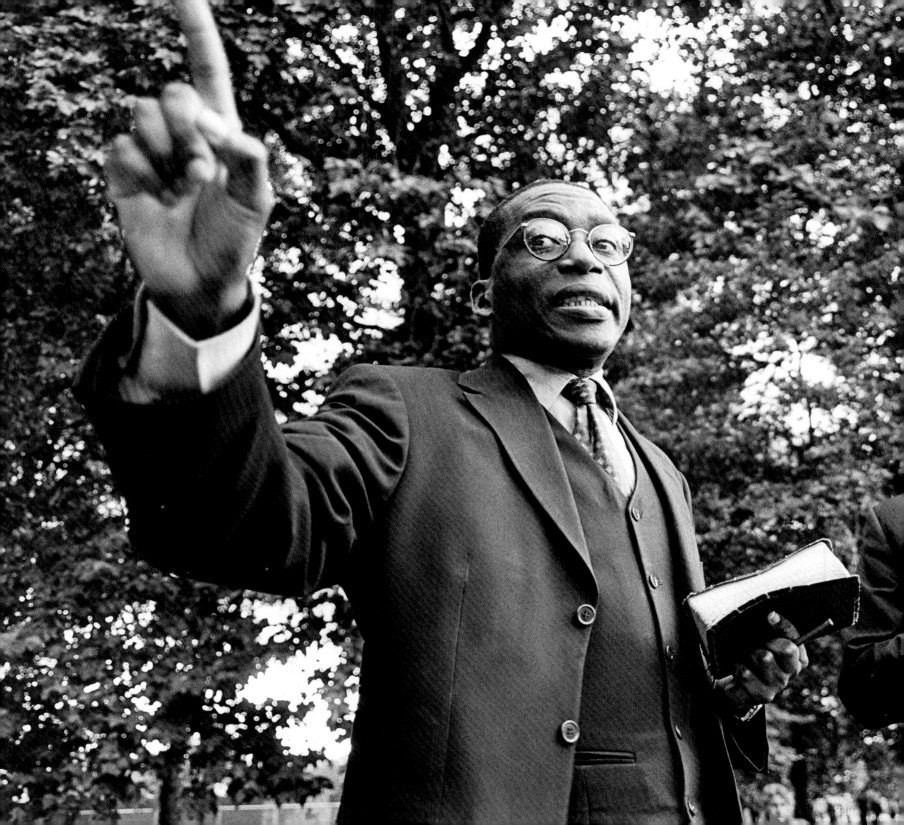

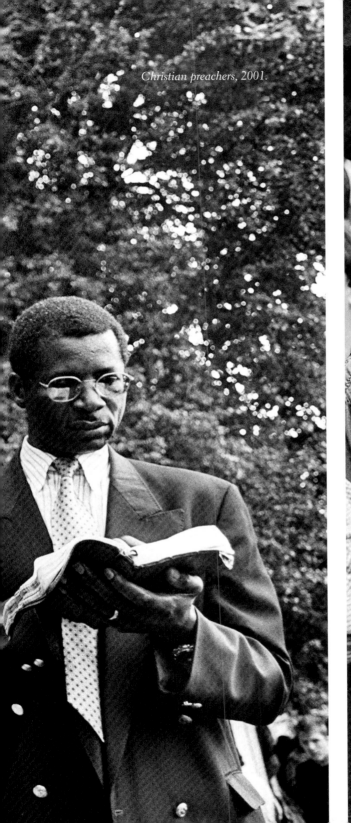

Christian preachers, 2001.

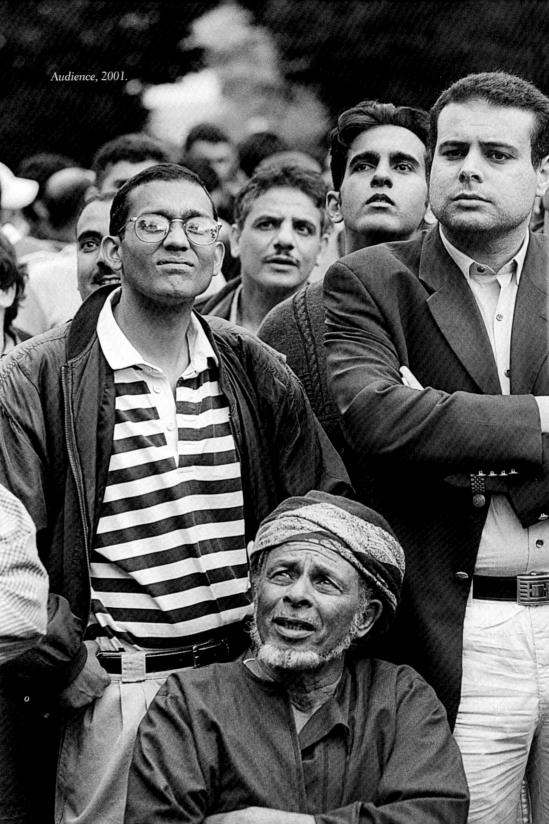

Audience, 2001.

Heiko Khoo: Why is it when I come to Speakers' Corner I hear people attack Communism? Because the Communists were stupid! Ignorant! Instead of advocating Communism around the world, they said, 'We'll create Communism in a backyard pigsty!' You can't do that. Communism must be worldwide or it can't be anywhere. You can't have Communism on an island like Cuba. Nonsense! Of course they destroy you! They could have had Communism in Western Europe, and through Communism in Western Europe you could have had Communism in America. Now, that is not something utopian and nonsensical – because look today: when a few peasants in Chiapas occupy land and say, 'This belongs to us, not to the landlords,' look at the panic it sparks off in the whole of the Western world. A few peasants who advocate Communism are a threat to the whole of the United States of America!

Heiko Khoo, 2001.

Tony Allen: I'm giving you an anti-globalisation perspective. The war on terrorism is exactly the same as the war on drugs, exactly the same as the war on Communism – it's a convenient media-friendly cover with which to protect America's interests. They had air supremacy in Afghanistan after about ten days – probably after about ten minutes – yet they've spent the next six weeks dropping bombs. What they're saying to the Sultan of Brunei, to the Saudi royal family, to various juntas around the world, is, 'Here's the latest bit of machinery you haven't seen. We've upgraded this since Bosnia, since Kosovo, here it comes over now. Are you all sitting comfortably? Have a look at your pamphlet.' It's a bloody trade fair!

Tony Allen, 2001.

Heckler, 2001.

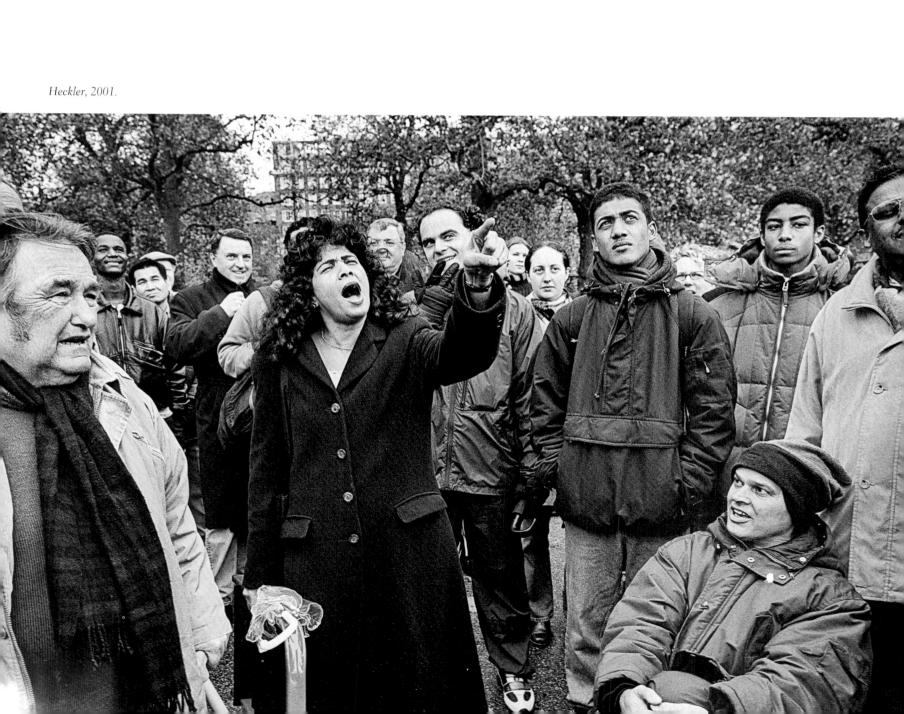

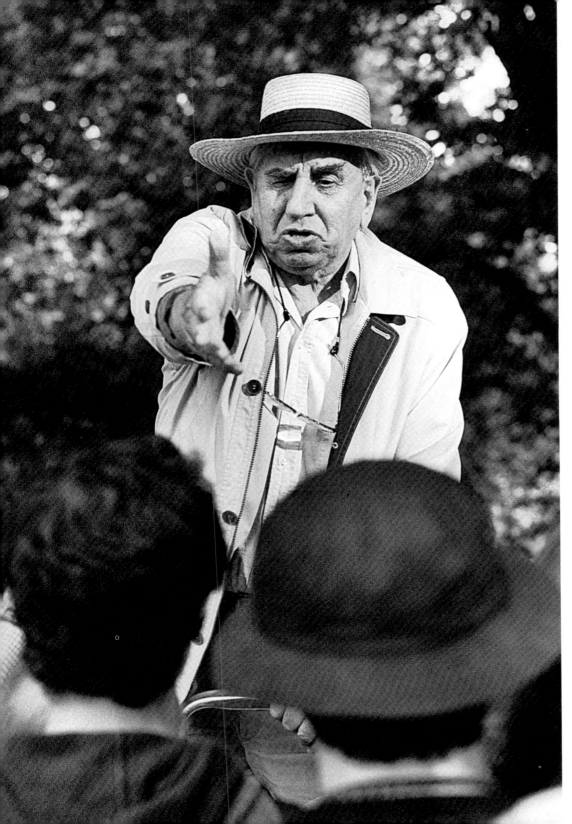

Simon: The priests, the archbishops, the mullahs – they are the most corrupt people in the world. How can we believe that there is God? People who are primitive, people with a low spirit, low self-esteem, people who are depressed, losers, loners – they need God. They need to believe and to get the consolation that if they pray, they go to Heaven and they get eternal life. There is no eternal life! There is no soul! Religion is opium for the people, as Marx said. To fight against terrorism we should fight against the religious mafia. In the States, in Palestine, in Afghanistan, throughout the world, these brainwashers are responsible for creating such evil, like these suicide bombers on the eleventh of September!

Simon, 2001.

Speaker: You're Irish. Why aren't you in Ireland?

Heckler: Why is it important where people come from?

Speaker: What's wrong with Ireland? God made you Irish. The world is being brought to an end because all of you are chancers who, if you don't get what you want where you are, you just move somewhere else. And woe betide anybody who speaks against you. God created the races. And what's going on in the world is because you couldn't care who you are. You betray your own land, your own forefathers, as long as you're cosy, comfortable and got what you want. And that is why Almighty God is stripping you bare and you're running out of places to run to. You are not where God ordained you to be. And you persecute anyone who has any loyalty to their own identity and their own homeland. And everyone you call a racist and a fascist, because you want to go where you like, is going to stand up in judgement before God and God Almighty is going to be on their side, not yours.

Diane, 2001.

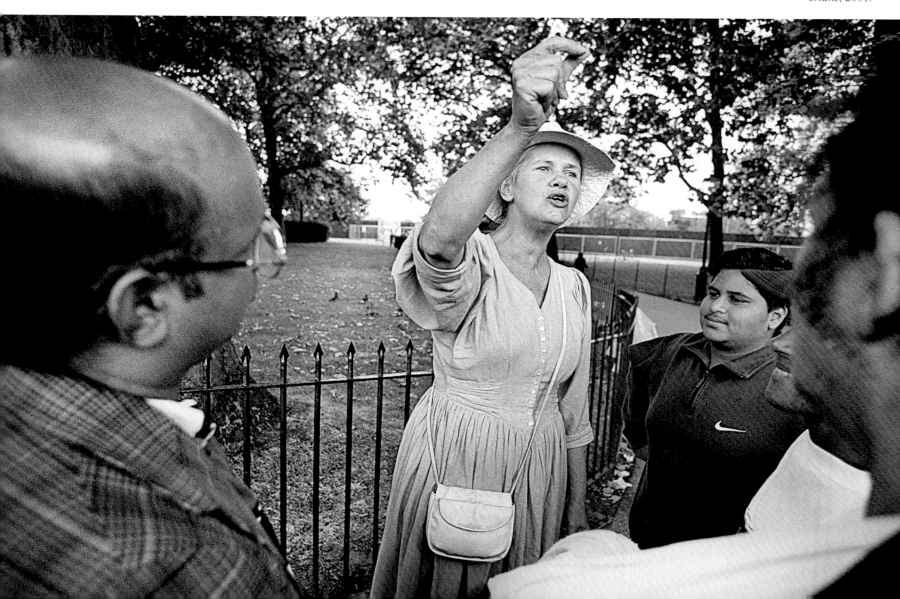

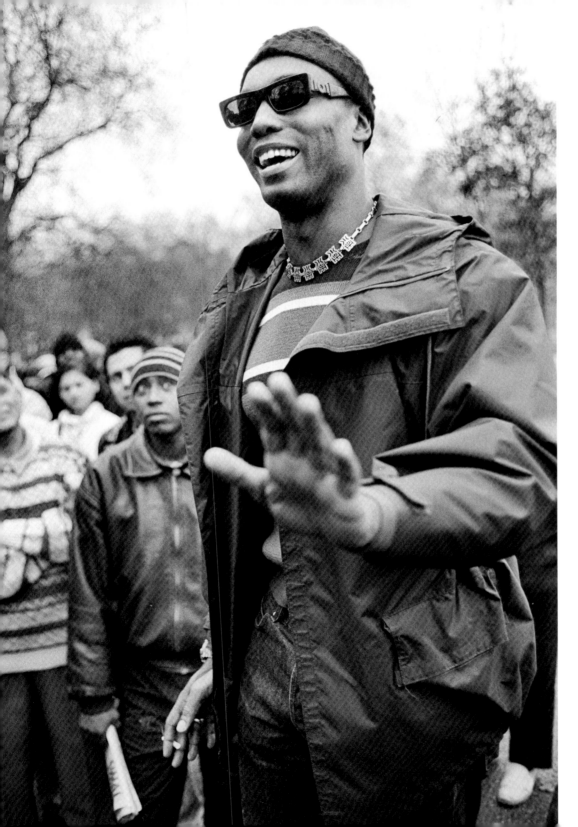

Ishmahil Blagrove: Tony Blair wants to be remembered. He wants to go down in history. Tony Blair isn't like the Americans. I don't even really believe Tony Blair supports American foreign policy. But Britain needs protection. Britain is running scared. Britain has armed forces of only 130,000 people. Before Britain allies itself with Europe, it runs clear across the Atlantic to another English-speaking nation, the Americans, with the most atrocious and inhumane foreign policy objectives that the world has ever known. They're on a mission of world domination. And the Americans rule the world! Without a doubt, this is the American Empire. When you are hungry and leave Hyde Park after listening to such a beautiful speech, where are you going to go to sate your hunger? McDonalds! Burger King! Kentucky! Wendy's! Pizza Hut! What trainers are you wearing? Nike! Puma! Adidas! Reebok! What's your favourite programme? *Friends*! *The Simpsons*! We are warped by American culture. America isn't in Afghanistan to get Osama Bin Laden. America is there to establish a Hollywood presence – and Coca-Cola and McDonalds. Look at Russia, when the Iron Curtain came down. What was the first company to open in Russia? McfuckingDonalds! And what was the propaganda? They showed queues of Russian people – thousands! – queuing up to buy a Big Mac! Can you imagine? They've just been freed from this oppressive, oppressive regime – and the first thing they desire is a Big Mac and a Coke! This is the extent of American globalisation. Every nation is running to curry favour with America, so they can get the crumbs from America's table.

Ishmahil Blagrove, 2001.

First Speaker: Let me give you an example. Imagine now, just imagine for a second, we see a flying object comes over here. Looks like a MIG 27, because we've seen a MIG 27, right? It says 'Love from America' or whatever. And then it drops an object; looks like a bomb. And it destroys all of us, right? And it flies away. The people over there, they witness this, and they start working out, you know what? There is a one in a trillion, trillion, trillion chance it's possible this is all by chance. It is possible that this is not designed. Do you think on planet earth – I'm not going beyond planet earth – on planet earth there will be any individual, scientist or otherwise, that will buy the theory that this was just pure chance?

Second Speaker: No there wouldn't, because it's obvious to anybody that this is a designed and manufactured product. But this world, and us, are not.

First Speaker: You didn't understand my argument. I'm not talking about life. I'm talking about matter, material. You are proposing this theory that, somehow in our universe, somehow, one of the combinations produced life, by pure random accident, without a designer?

Second Speaker: There is no evidence for a designer.

First Speaker: I propose to you a similar thing. That object that hit us, it wasn't a bomb. It wasn't a MIG 27. Just because it says it's MIG 27, and it looked like MIG 27, and it dropped something that looked like a bomb, it is nothing to do with anyone who designed it. It is an apparent illusion! It is an illusion of design. Don't you get that?

Debate, 2012.

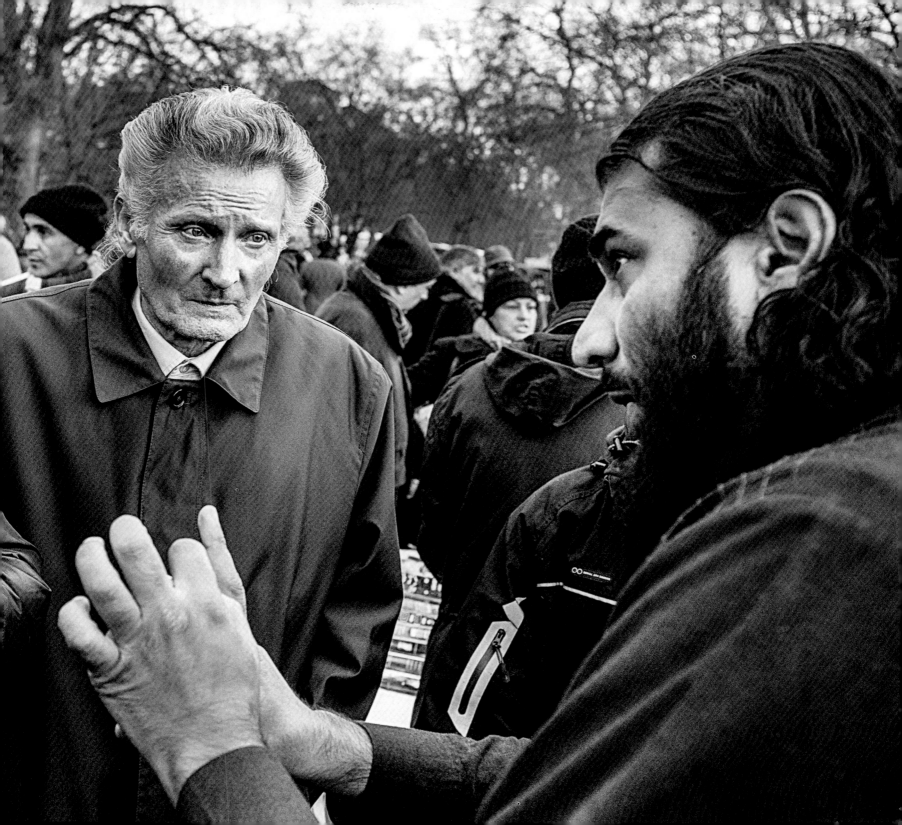

Preacher: The Brotherhood of the Cross and Star, 2014.

Preacher: The Muslims must live in peace with
the Christians! The Christians must live in peace
with the Muslims! Otherwise they will all perish!

Speaker: 9/11 was like the gas chamber thing: it was a hoax.

First Heckler: So the buildings are still there, right? Behind a blue curtain or something?

Speaker: No, do you know what happened to the buildings?

Heckler: They fell down!

Speaker: No! No! They did not! The buildings were turned to dust.

First Heckler: I've had enough of this. You're mad!

Speaker: When you laugh, you're showing the world that you're stupid! Because anybody who's studied 9/11 at all for more than five minutes knows that the building did not collapse, it was turned into a dust cloud. Both buildings. Look, she's laughing! There's no point talking to you if you don't even know about 9/11. The Americans, the New World Order, have got a technology – they can turn buildings to dust. The same way they can drone anyone is the world, they've got the technology to turn anywhere in the world to dust if they want to.

Second Heckler: Can they turn you on?

Third Heckler: No, only off.

Speaker: I can't understand. The white people here, they've had free education, the Internet, and when you talk about 9/11 being an inside job, they laugh! You know, I'm not really a speaker. You know why I'm here talking? Because the speakers in Hyde Park, especially the socialists, get on my tits! That's why I speak.

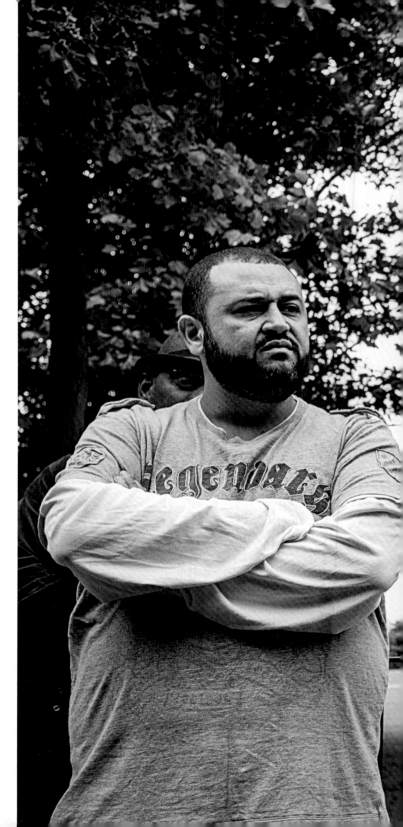

Conspiracy theorist, 2014.

110

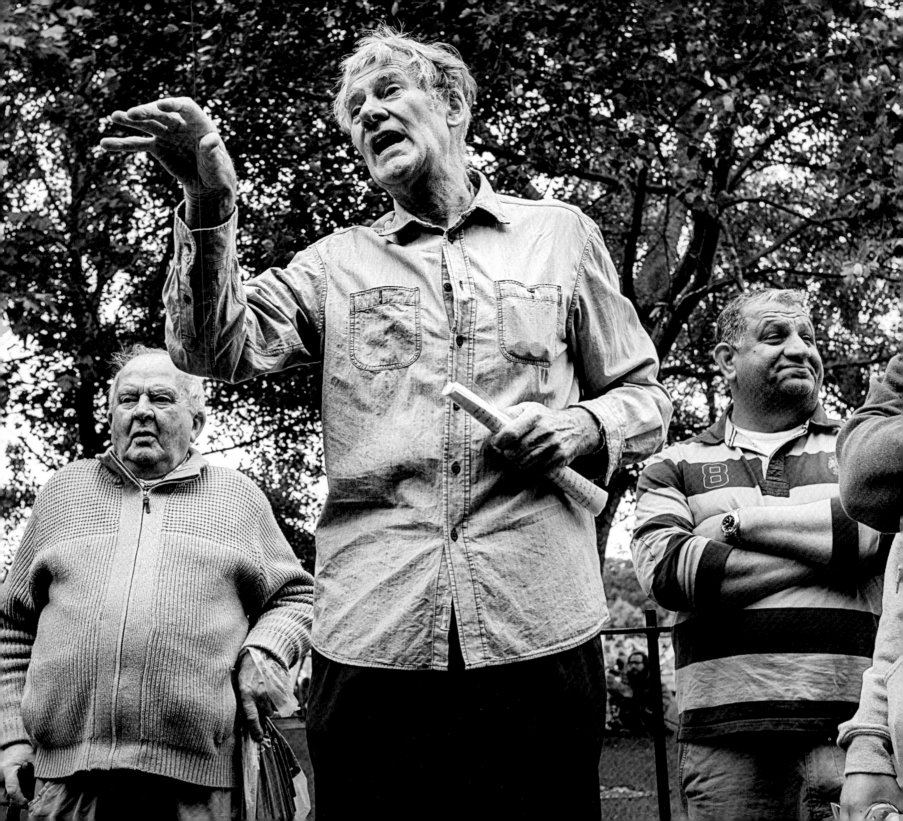

Christianity v. Islam argument, 2014.

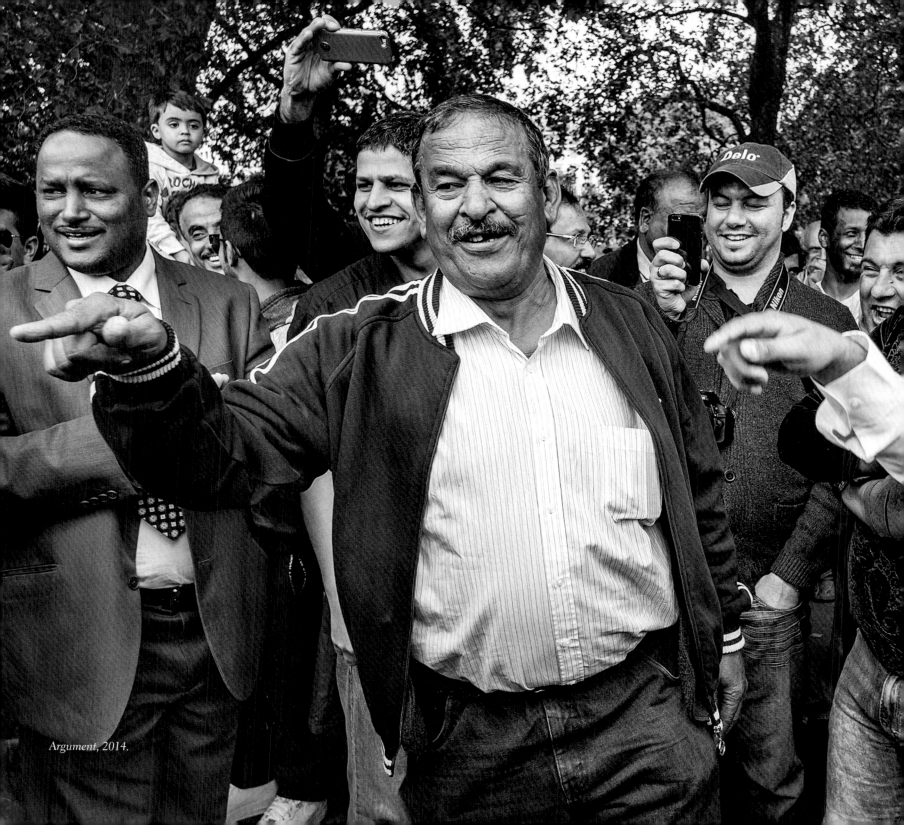

Argument, 2014.

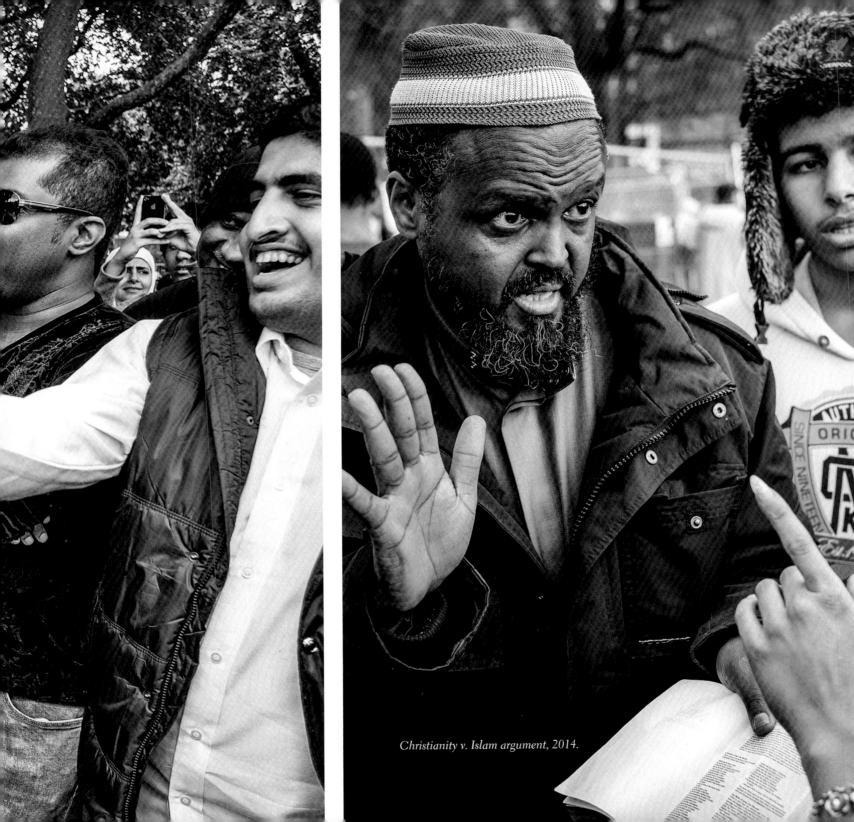

Christianity v. Islam argument, 2014.

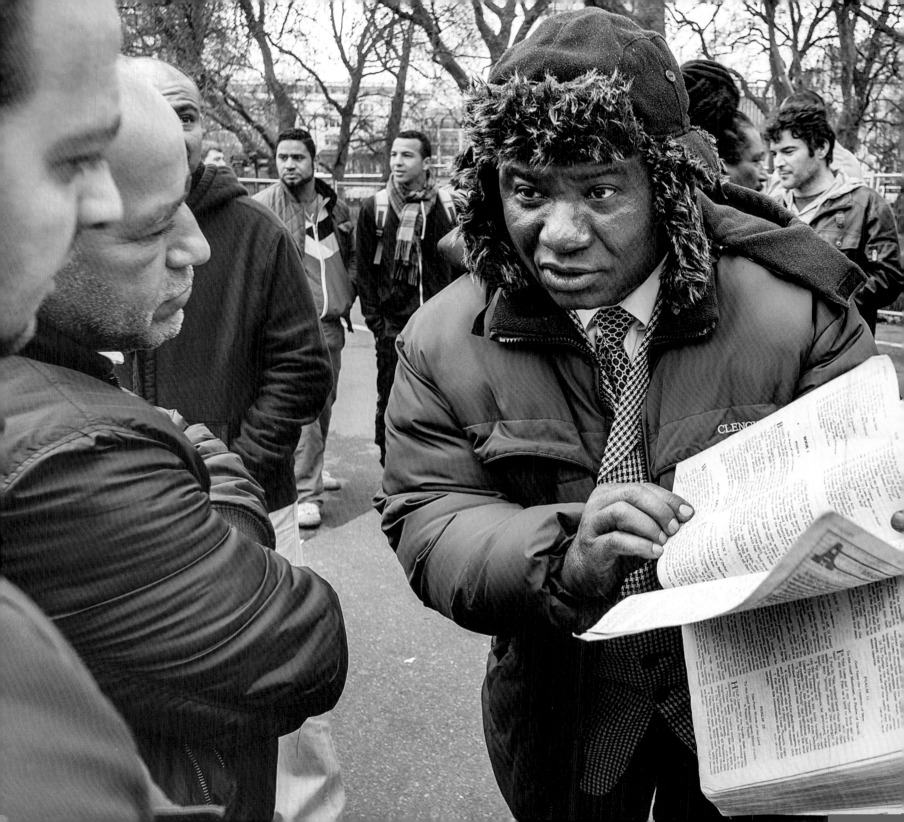

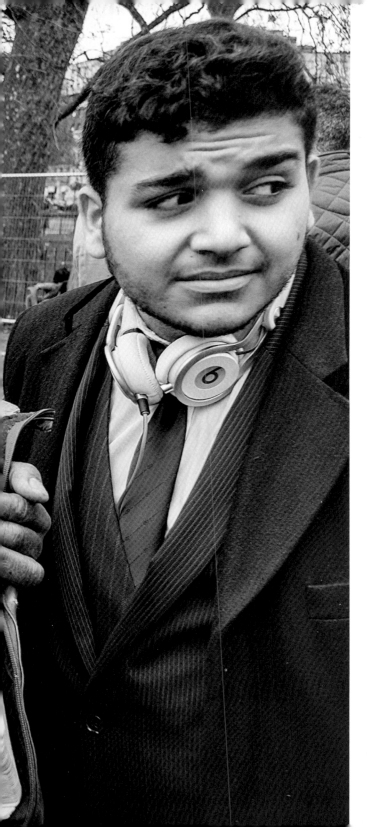

Bible scholar, 2014.

Man in crowd: You're so wholly negative about everything!

Heiko Khoo: I'm not negative about anything. I'm describing what is.

Man in crowd: What do you want? Give us something positive, not all this negative bullshit!

Heiko Khoo: Critiquing something, my friend, that is the essence. You see, Karl Marx – people complain about what he wrote. They say he never proposed what should happen under Socialism, he just criticised. Why criticism? Criticism is the foundation for you to decide what happens! If I tell you we should to A, B or C – nationalise the banks, nationalise the monopolies, have democratic control over production – I can say that in three sentences, or less – one sentence. It's a slogan. The essence of what it means is determined by the mindset that the people adopt when they think about what is and how it might come to change. Therefore criticism is the foundation for all knowledge and all advance of knowledge. That's why my discussions at Speakers' Corner focus on criticism of what is. Because by criticising what is, each individual can think 'this could be done differently, that could be done differently'. Now I may not agree with what you say, you may not agree with what I say, as alternatives. But once we engage in a common understanding of what is wrong, then we can engage collectively in thinking about what should be organised differently.

Heiko Khoo, 2014.

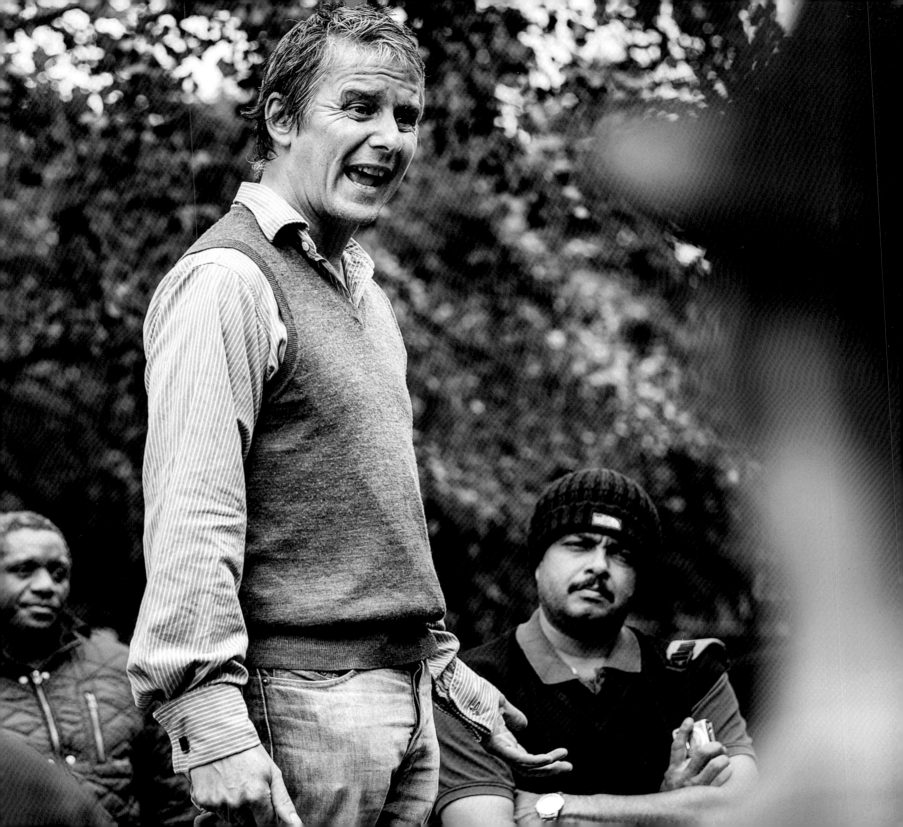

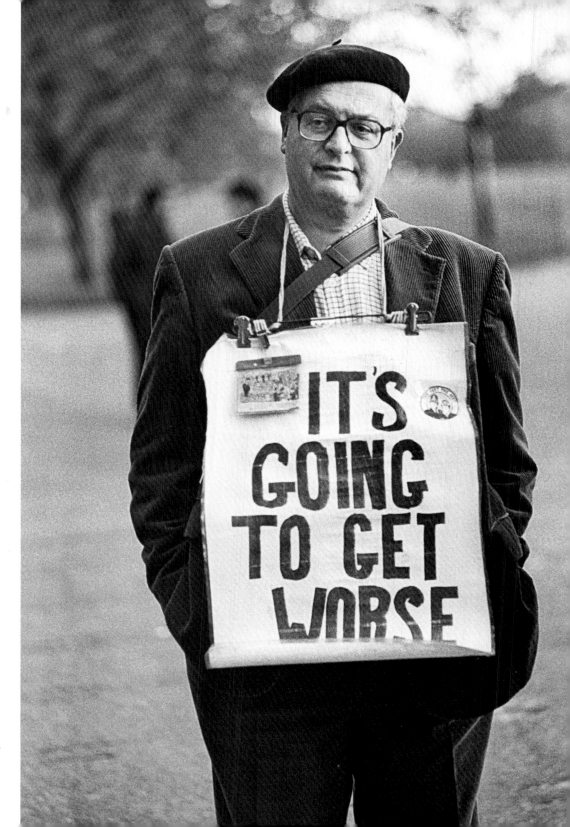

Bob Rogers, 2001.